P9-CLD-510

the KODAK Workshop Series

Black-and-White Darkroom Techniques

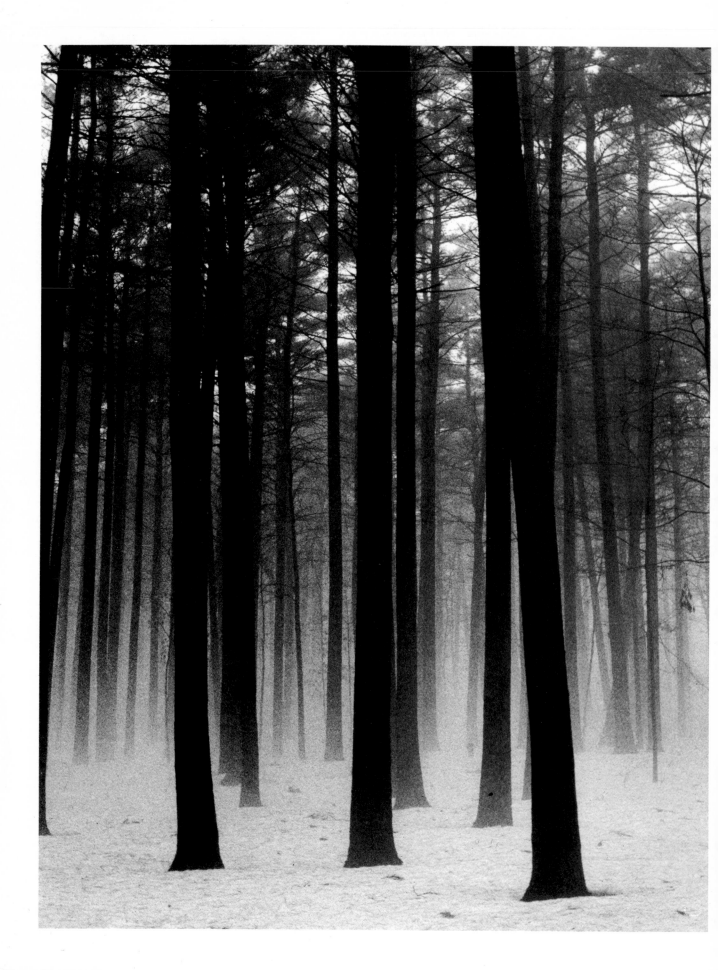

the KODAK Workshop Series

Black-and-White Darkroom Techniques

FOR BEGINNING and INTERMEDIATE PHOTOGRAPHERS

Written for Kodak by Hubert C. Birnbaum

*As shown by the enlargement **at left,** black-and-white print making is an exciting art form, offering a rewarding medium for self expression. For information on ways to control the subtleties of contrast variation in your black-and-white prints, see pages 75–77.*

The KODAK Workshop Series

Helping to expand your understanding of photography

Black-and-White Darkroom Techniques

Written for Kodak by Hubert C. Birnbaum

Kodak Editor: Keith A. Boas

Book Design: Quarto Marketing Ltd.,
212 Fifth Avenue
New York, New York 10010

Designed by Roger Pring

Photography by the photographic staff of
Eastman Kodak Company except as follows:

Page 2, David Haase
Page 5, Robert L. Clemens
Page 7, Richard Below
Page 28, Anthony Boccaccio
Page 29 (top), Anthony Boccaccio
Page 45, Fred C. Troge
Page 46, Sandra Salazar
Page 47, Stephanie Ruzicka

Page 49 (top), Josef Szadav
Page 49 (bottom), J. Adam
Page 52 (top), Darnella Craddock
Page 52 (bottom), Arthur Underwood
Page 54, Sharon Reap
Page 55 (top), Rebecca Mason
Page 57, David Nagao
Page 64 & 65, William J. Fiore

Page 66 (left), D.M. Skolinik
Page 74, Jeff Sedlik
Page 75, Mark Engbrecht
Page 76, Norm Kerr
Page 84, Wendi Morrison
Page 88, Delton Baerwolf
Page 93 (bottom), John Holland
Page 95, Frank Gimpaya

© Eastman Kodak Company, 1986

Photographic Products Group
Eastman Kodak Company, Rochester, N.Y. 14650

Kodak publication KW-15
CAT 144 0809
Library of Congress Catalog Card Number 81-67033
ISBN 0-87985-274-7
7-86 CX Minor Revision
Printed in the United States of America

*Throughout this book Kodak products are recommended.
Similar products may be made by other companies.*

*Measurements shown in this book are U.S. customary units followed
by the metric equivalent either in italic type or in parentheses.*

KODAK, PHOTO-FLO, DATAGUIDE, POLYCONTRAST, MICRODOL-X,
HC-110, DK-50, KODABROMIDE, KODABROME, KODALITH, EKTAMATIC,
EKTALURE, PANALURE, DEKTOL, EKTAFLO, SELECTOL, SELECTOL-SOFT,
EKTONOL, AZO, VELOX, ROYALPRINT, D-76, TRI-X, ELITE,
POLYFIBER, POLYPRINT, and DURAFLEX are trademarks.

The photograph below is printed on KODAK ELITE Fine-Art Paper, the finest black-and-white paper Kodak has ever made. This paper's silver-rich emulsion reproduces the wide tonal range of superior black-and-white fine-art photography. The result is deep, rich blacks, brilliant clean whites, neutral grays, excellent shadows and highlights, and finely rendered detail. This paper allows for increased creativity and greater control in printing.

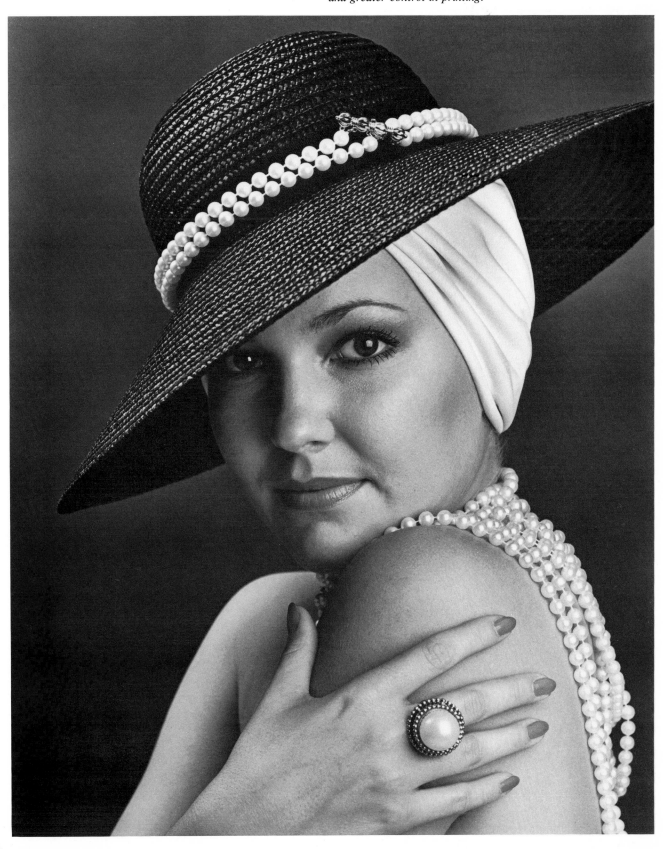

Contents

Processing film

For many photographers, taking the picture is only the first step in a multi-faceted photographic involvement. Rather than send black-and-white film to a photofinisher or custom laboratory for developing and printing, they do it themselves. There are many good reasons for doing your own darkroom work: the satisfaction of learning more about photography; the opportunity to exercise direct, personal control over every step in the image-making process; the potential for adapting standard procedures to suit better your personal tastes; and not least, the thrill of seeing a picture come alive in the glow of a darkroom safelight. There are at least as many reasons as there are photographers, probably more.

READ DATA SHEETS AND INSTRUCTIONS
Your first step is to read the data sheets and instructions supplied with materials and equipment. Film processing is like cooking: You increase your chances of success if you familiarize yourself with the entire recipe before you begin. The fewer surprises the better.

THINGS YOU'LL NEED

1. Plastic or metal daylight developing tank
2. One or more film reels in appropriate sizes
3. Bottle-cap lifter (for opening 35 mm magazines)
4. Blunt-end scissors
5. Developer
6. Stop bath *optional*
7. Fixer
8. Two or three containers for developer, stop bath (if used), fixer, and general measuring use
9. Two airtight storage bottles for developer and fixer
10. Stirring rod or paddle for mixing solutions
11. Darkroom thermometer
12. Large plastic pail
13. Wetting agent
14. Hypo clearing agent or wash accelerator
15. Weighted and unweighted film clips
16. Darkroom timer
17. Medium-size plastic funnel
18. Negative filing envelopes or sleeves
19. Changing bag (if no darkroom is available)

Good darkroom timers are accurate and easy to read quickly. Analog and digital models are available. Pick the display mode with which you are most comfortable.

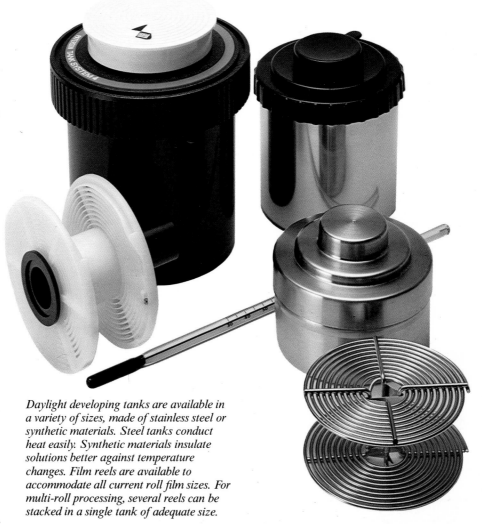

Daylight developing tanks are available in a variety of sizes, made of stainless steel or synthetic materials. Steel tanks conduct heat easily. Synthetic materials insulate solutions better against temperature changes. Film reels are available to accommodate all current roll film sizes. For multi-roll processing, several reels can be stacked in a single tank of adequate size.

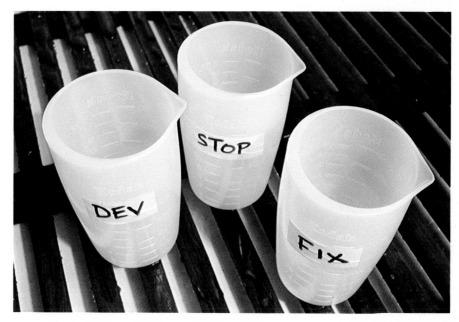

Mark containers prominently to avoid using solutions in the wrong order.

Typical developing data, found in product support literature, include a list of recommended developers and dilutions with suggested developing times and processing temperatures. When processing with tank sizes described in this book, use data listed under the Small Tank *heading. The data in this table refer to* KODAK TRI-X Pan Film, *size 135.*

| KODAK Packaged Developers | DEVELOPING TIMES IN MINUTES* | | | | | | | | | |
|---|---|---|---|---|---|---|---|---|---|
| | SMALL TANK†—Agitation at 30-Second Intervals | | | | | LARGE TANK—Agitation at 1-Minute Intervals | | | | |
| | 65°F 18°C | 68°F 20°C | 70°F 21°C | 72°F 22°C | 75°F 24°C | 65°F 18°C | 68°F 20°C | 70°F 21°C | 72°F 22°C | 75°F 24°C |
| HC-110 (Dilution B) | 8½ | 7½ | 6½ | 6 | 5 | 9½ | 8½ | 8 | 7½ | 6½ |
| D-76 | 9 | 8 | 7½ | 6½ | 5½ | 10 | 9 | 8 | 7 | 6 |
| D-76 (1:1) | 11 | 10 | 9½ | 9 | 8 | 13 | 12 | 11 | 10 | 9 |
| MICRODOL-X | 11 | 10 | 9½ | 9 | 8 | 13 | 12 | 11 | 10 | 9 |
| MICRODOL-X (1:3) | — | — | 15 | 14 | 13 | — | — | 17 | 16 | 15 |
| DK-50 (1:1) | 7 | 6 | 5½ | 5 | 4½ | 7½ | 6½ | 6 | 5½ | 5 |
| HC-110 (Dilution A) | 4¼ | 3¾ | 3¼ | 3 | 2½ | 4¾ | 4¼ | 4 | 3¾ | 3¼ |

NOTE: Do not use developers containing silver halide solvents.
*Unsatisfactory uniformity may result with development times shorter than 5 minutes.
†Usually one-quart size or smaller.

CHOOSING A DEVELOPER

For best results, select a developer recommended by the film manufacturer. Frequently, several different developers may be recommended. Choose one that is available in quantities small enough or large enough to meet your needs with minimal waste. Avoid developers that require developing times shorter than about 4 minutes, because they are inconvenient to use with pour-in/pour-out daylight tanks and may produce poor uniformity at these short times.

Some developers, known as single-shot or single-use developers, are discarded after one use. Others are formulated so that they can be chemically replenished after each developing session and saved for reuse. If you develop small quantities of film on an occasional basis, single-shot development entails few storage and spoilage problems and yields negatives of excellent consistency. Developers requiring replenishment are best suited to processing large quantities of films frequently. Used to capacity, they are extremely economical. Some developers can be used either way: diluted for single use, or full strength with a replenishment procedure.

Some popular Kodak developers available in package form include KODAK HC-110 Developer, KODAK Developer D-76, and KODAK MICRODOL-X Developer. HC-110 and D-76 Developers produce negatives of maximum film speed and shadow detail with normal contrast and fine grain. MICRODOL-X Developer yields negatives of finest grain with minimum speed loss with most films. KODAK HOBBY-PAC Black-and-White Film Processing Kit offers results similar to HC-110 Developer with the convenience of a kit and premeasured chemicals.

For your safety

Care is required in handling all chemicals. Photochemicals are no exception. It is advisable to wear protective gloves to prevent skin contact with photographic chemicals. Safe handling information for a particular Kodak chemical can ordinarily be obtained from the product label or a Material Safety Data Sheet. Direct purchasers of Kodak chemicals will automatically receive these sheets one week after purchase. Others may request them by writing to Charlene Nowakowski, Marketing Administrative Services, Eastman Kodak Company, 343 State Street, Rochester, N.Y. 14650, or by calling the toll-free number 1-800-445-6325, Ext. 25. Include catalog number for the product in question. See also Kodak publication J-4S, *The Prevention of Contact Dermatitis in Photographic Work*.

MIXING AND STORING CHEMICALS

Follow mixing instructions to the letter. When stirring powdered developers into solution, stir gently and smoothly. Air bubbles beaten into the solution can cause premature oxidation and weakening of the developer.

Stop bath and fixer can be mixed immediately prior to use. When adding a powdered fixer to water, trickle the powder into the liquid slowly while stirring. Adding the powder too rapidly can cause formation of hard lumps that require seemingly endless stirring to dissolve.

Chemical storage bottles should be assigned permanent functions and labeled appropriately. If absolutely necessary, a bottle originally used to store developer may be switched later to storing stop bath or fixer if rinsed

thoroughly. Don't store developer in a bottle that once held stop bath or fixer. Minuté traces of the original contents could weaken developer that comes in contact with them for long periods.

Store mixed solutions, unused or partially used, in full, tightly capped containers at normal room temperatures. This is especially important with developers. When a developer solution comes in contact with air, it ages quite rapidly due to oxidation. Plastic squeeze bottles that can be collapsed to eliminate airspace above the solution level make ideal storage containers for developers. Ordinary bottles will do for other chemicals, providing you keep them capped.

Label chemical storage bottles as to contents and the date mixed.

Kodak publishes tables showing safe life expectancies for darkroom chemical products. Recommended storage times usually fall within several weeks or months. Discard overage chemicals as they have probably lost much of their strength. Some chemicals, particularly stop baths and fixers, may be saved for later reuse. Consult manufacturers' data for maximum working capacity, and do not exceed it.

Photographic chemicals keep best in cool places. If you live in a cold climate, though, don't keep solutions in unheated areas. Excessively low temperatures may cause chemical constituents to precipitate or crystalize out of solution irreversibly.

Black-and-White Processing Using KODAK Chemicals (J-1) and the KODAK Complete Darkroom DATAGUIDE (R-18) include tables that cover the keeping properties and working capacities of Kodak processing chemicals. Both books, available through photo dealers, provide a wealth of detailed information of interest to the black-and-white darkroom worker.

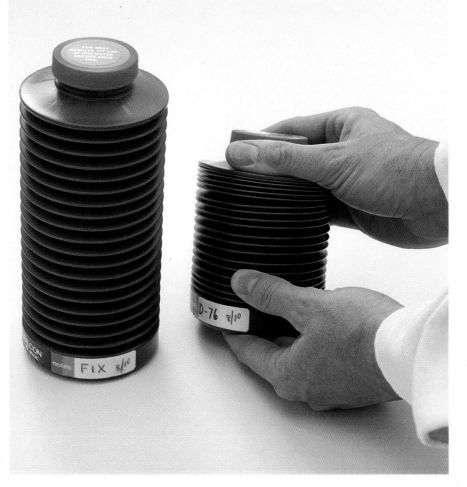

Plastic containers that can be squeezed to reduce air space above their contents are useful for storing processing solutions. Label the containers to show content and date prepared.

TEMPERATURE CONTROL

Processing films by time and temperature requires accurate control of both to produce repeatable results. Precise timing is easy to achieve. Precise temperature control is often more difficult.

Developer that is *too warm* will *overdevelop* film. Developer that is *too cool* will *underdevelop* film. Recommended developing temperatures for most black-and-white developers are 68°F *20°C* and 75°F *24°C*, depending on the specific product. Data for KODAK black-and-white films frequently list the developing times for 65°F *18°C*, 70°F *21°C*, and 72°F *22°C*, as well. If you pick a processing temperature that corresponds closely to the ambient temperature in your darkroom, it will facilitate temperature control. Ideally, all processing solutions and water washes should be the same temperature as the developer. Actually, variations up to about plus or minus 5°F *plus or minus 3°C* from the developer temperature can be tolerated.

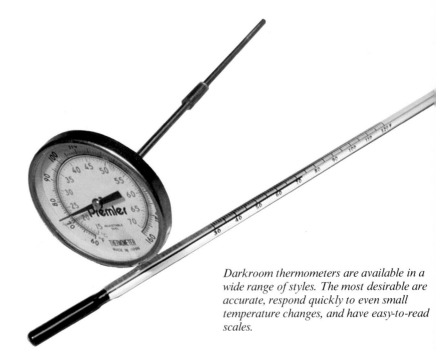

Darkroom thermometers are available in a wide range of styles. The most desirable are accurate, respond quickly to even small temperature changes, and have easy-to-read scales.

To bring chemicals to proper temperature, fill a deep tray or pail with water a few degrees warmer or cooler than the desired temperature depending on whether the solutions must be warmed or cooled. Place the chemical bottles, or graduates filled with measured amounts of the solutions, into the water bath. Let them stand until they reach the desired processing temperature. When they do, adjust the temperature of the water bath, if necessary, to match the processing temperature. The comparatively large quantity of liquid in the water bath changes temperature slightly, preventing the relatively small quantities of chemical solutions it surrounds from changing temperature rapidly.

The temperature of running water for washing film is best controlled with a thermostatic mixing valve. If you don't have one in your darkroom, you'll have to balance the cold- and hot-water flow manually. Monitor water temperature with a quick-responding darkroom thermometer. Alternatively, set aside a bucket of water at the proper temperature to use if the tap water defies temperature control.

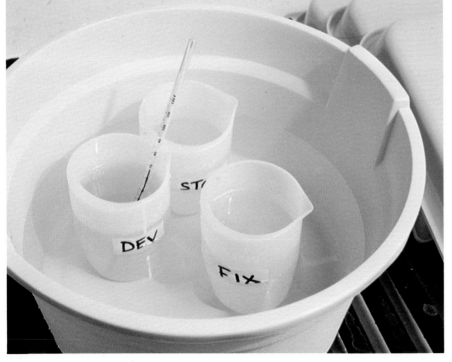

Use a water bath to establish and maintain correct processing temperature of solutions before and during processing. Arrange labeled graduates or bottles in order of use to reduce the chance of a mix-up.

LOADING YOUR TANK

With most film tanks, only the loading of the tank requires a darkroom or other totally dark environment. You can check an improvised darkroom, such as a closet or bathroom, for adequate darkness by placing a sheet of white paper on the work surface where you will be handling film. Close the door, cover light leaks as you would when actually loading film, and remain in the dark for at least 5 minutes. If you cannot see the white paper after 5 minutes, the area is dark enough. Or, you can load film tanks in a changing bag, which eliminates the need for a darkroom.

In the darkroom, or when using a changing bag, arrange tank, lid, reels, film magazines, cartridges or rolls, cap lifter (if needed), and scissors (if needed) so that you know where they are relative to each other. The tank body, the largest object, is a good landmark. Turn off the lights or close the changing bag.

Opening film magazines and cartridges
With 35 mm magazines, *above,* use the cap lifter to pry off the end cover opposite the end from which the spool protrudes. Slide the spool from the shell and, using scissors, clip the narrow leader section from the strip.

To open 110- and 126-size film cartridges *below,* and *right,* bend the end receptacle containing exposed film toward the label to break the cartridge. Separate the film chamber sections to remove rolled 126 film and backing paper. To remove 110 film, strip the film and backing paper from the cartridge slowly, making sure that only the paper backing, not the film, touches the cartridge edges. Separate the film from the paper and load the film onto the reel.

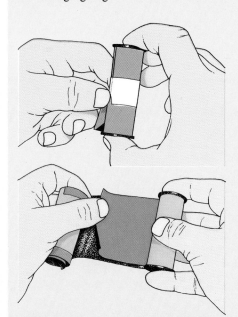

With 120-size and other conventional roll films, *above,* tear the paper sealing strip and separate the film from the paper backing. Peel away the tape that secures the end of the film to the paper.

When handling paper-backed films, be certain that you have loaded the film rather than the paper backing onto the reel. The film feels stickier and more resilient than the paper.

LOADING THE REEL

Load the reel according to the manufacturer's instructions either in a room that is totally dark or a special light-proof changing bag. When you reach the end of the roll, snip the film free of the spool with a pair of scissors. If it is taped in place, you can simply peel the tape from the film. Do so slowly to avoid tearing the film or generating static sparks (see page 20). Next place the loaded reel in the tank. When all reels are in the tank, place the lid on it securely before turning on the lights or removing the tank from the changing bag.

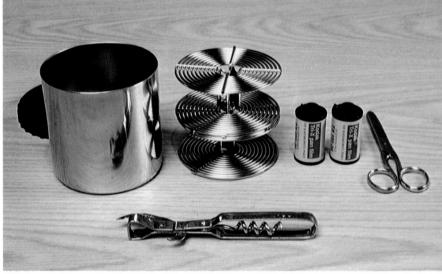

Always arrange your tank, lid, reels, scissors, film magazines, and cap lifter in the same order before turning off the light. Uniform setup makes it easier to find things in the dark or in a changing bag.

LOADING METAL REELS

Handle film only by the edges, to avoid putting finger marks on the picture area.

Remember that total darkness is a *must* during this operation. If you are unfamiliar with loading film into a tank, you may want to practice first with the lights on, using a roll of outdated, scrap film.

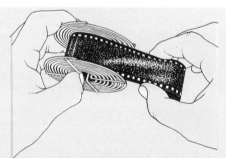

Stainless steel spiral reels generally load from the core outward, and plastic reels generally load from the outside toward the center. Follow loading

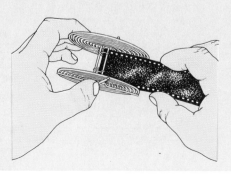

instructions exactly to ensure that the film lies smoothly in the guide channels. If you feel unusual resistance or buckling, back the film out a few inches and try again. Take your time and work smoothly. Be sure that your hands and the reels are completely dry.

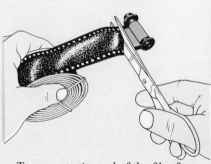

To separate the end of the film from a size 135 spool, use scissors. With roll film that is taped to its backing paper, carefully peel the tape from the film.

LOADING PLASTIC REELS

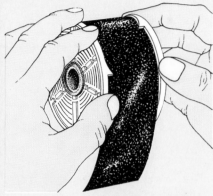

Some plastic reels must be loaded by feeding film into the retaining spirals from the outside toward the core. Be sure such a reel is absolutely dry before attempting to load it, as damp spots in the retaining channels can cause bulky feeding. Follow the manufacturer's loading instructions carefully.

AGITATION

Agitate the tank at regular intervals to assure even development. Specific agitation schedules are recommended for various film/developer combinations. A typical agitation program calls for rapping the tank bottom sharply against the sink or counter immediately after starting development to dislodge air bubbles that may have adhered to the film emulsion. Then agitate for 15 seconds. After the first 30 seconds of development have elapsed, agitate the tank for 5 seconds, and continue agitating for 5 seconds out of every 30 seconds of developing time thereafter. A tank that seals tightly can be agitated well by inverting it and rotating it on its axis at a rate of two full inversion cycles in 5 seconds.

Smooth, gentle motions work best. Exactly what you do is less important than the consistency with which you do it, but avoid extremes. Excessive agitation will cause overdevelopment, while insufficient agitation will cause uneven development and underdevelopment.

If the temperature of your darkroom is warmer or colder than the temperature of your developer, place the tank in the water bath between agitation cycles. This procedure will maintain proper processing temperature.

DEVELOPMENT

If you can, start development in the dark by placing the loaded reel or reels into a tank previously filled with developer at the correct temperature. This method will usually provide the greatest uniformity of development. Start the timer, close the tank, and turn on the light.

If this isn't a practical approach for you, close the tank and begin

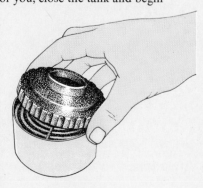

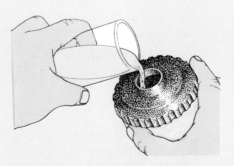

development in room light by pouring the developer solution through the light-baffled filler in the lid of the loaded tank. Most tanks fill more easily if tilted slightly. Start the timer as soon as the tank is full; then cap the tank lid to close the filler.

Whenever you are using a tank large enough to hold more than one reel, place enough empty reels above a lone, loaded reel to prevent it from shifting position during processing. And measure enough solution to fill the tank even when developing less than a full load of film.

If your tank can be inverted without spilling its contents, agitate by turning it upside down while simultaneously rotating it on its axis. Then right it while rotating it in the opposite direction. Hold the lid firmly in place to prevent accidental opening.

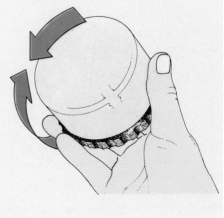

AGITATING NON-INVERSION TANKS

A tank that cannot be inverted without spilling can be agitated properly by sliding it back and forth about 10 inches *25 cm* at a rate of two cycles per second. Rotate the tank a half turn in each direction while sliding it.

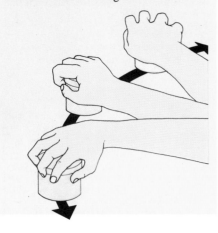

VARYING DEVELOPMENT

Manufacturers' recommended developing times work well for most people most of the time. However, if you find that your negatives are consistently denser (darker) or thinner (lighter) than you like, first check your meter and camera equipment to determine if your exposure was correct. If exposure was apparently normal, your developing equipment or methods may be producing the consistently dense or thin negatives. Shorten or lengthen developing times accordingly to produce negatives with printing characteristics you prefer. When experimenting with developing time, make changes in plus or minus 10 percent increments to avoid going too far.

Similarly, if over a period of time your negatives are consistently too harsh and contrasty to print easily, reduce developing time until a more normal contrast range results.

For negatives that are consistently too flat and lacking in contrast, increase developing time to obtain more sparkle.

Judging negative quality by eye can be difficult, even for experts. Don't jump to conclusions about development changes solely on the basis of visual inspection of your film. Consider primarily the quality of prints made from the negatives. Within reasonable limits, the way a negative looks to the eye is less important than the way it looks to the printing paper. If you can make good prints easily, there is probably no need to alter your developing procedures.

As the end of the developing time approaches, uncap the tank filler (do not remove the lid) and begin draining developer. Start this draining procedure enough in advance to empty the tank just as the timer indicates the end of development. The drain time may run from about 5 to 20 seconds, depending on your tank. Note the time that it takes to drain each tank you use.

STOP BATH or WATER RINSE

Fill the tank with stop bath diluted according to the manufacturer's instructions, or with plain water, and agitate the tank vigorously and continuously for 30 seconds or as specifically directed. This action halts development and washes remaining developer from the film and tank. Drain the tank. Stop bath can be saved for reuse. Because of its acid nature, stop bath will more quickly neutralize developer than will a plain water rinse. It will also help prevent developer carry-over to the fixer, which is an important consideration if you plan to process a lot of film and still want to reuse your fixer later. Most fixer capacity tables are based upon the use of a stop bath.

FIXER

Fill the tank with fixing solution, set the timer for the specified time, and agitate the tank briskly as recommended. When the fixing time is up, drain the tank, saving the fixer for reuse if desired. The fixer should be the same temperature as the developer. Fixing time is 2 to 4 minutes with KODAFIX Solution; 5 to 10 minutes with KODAK Fixer.

WASHING FILM

To prevent later deterioration of the film, all traces of fixer must be washed from the film before drying. With running water at a stable temperature approximating the processing temperature, direct the flow through the center of the reel(s) in the opened tank.

Water will be forced down to the bottom of the tank and then up through the spirals of the reel, carrying away fixer. A 30-minute running-water wash is usually adequate, but check the film manufacturer's recommendation.

DRYING FILM

Hang the film to dry in a clean, dust-free, draft-free, dry area. A weighted film clip on the bottom end of the strip will keep it hanging straight. Immediately after hanging up the film, wet the fingers of one hand thoroughly with diluted wetting agent and gently squeegee the film between two fingers, sandwiching it lightly between them. This removes excess surface moisture with minimal risk of scratching the film. For even faster drying, you can carefully wipe the film with a soft, viscous sponge or chamois, previously saturated with diluted wetting agent and wrung out.

Drying time varies greatly with the relative humidity. If fast drying is required, a drying cabinet that circulates heated, filtered air can be used. Such cabinets are available commercially in a wide range of sizes, or you can build one if you're handy with tools. For occasional rapid drying, you can use a hand-held hair dryer.

Cleaning your equipment

While waiting for film to dry, clean all processing equipment and the work area. If you clean up before chemical residues have caked and hardened, they rinse off easily. If you wait, vigorous scrubbing may be required. Be particularly careful to wash away all traces of the wetting agent solution from your tank and reels. The wetting agent may contain chemicals that weaken developer as well as produce bubbles when you agitate the developer. Dry metal utensils promptly to prevent rust and stains.

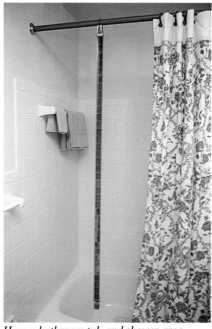

Here a bathroom tub and shower area serves as a dust-free, out-of-the-way space for drying processed film. Note that a film clip is attached to the bottom of the roll to prevent buckling during drying.

A series of still-water rinses may be substituted if a running-water wash is not practical. Fill the tank with clean water at the process temperature, soak the film for 5 minutes, dump the water, and refill. Repeat for a total of six 5-minute soaks.

Chemical washing aids

You can shorten the washing time and save water by using a washing aid such as KODAK Hypo Clearing Agent to purge fixer from the film rapidly. When it is necessary to use KODAK Hypo Clearing Agent, rinse the film in clean water for 30 seconds after fixing. Then agitate the film in the clearing agent solution for two minutes and end with a five-minute water wash. When maximum image stability is a requirement or for use of this agent with paper, refer to Kodak publication F-40, *Conservation of Photographs*.

Wetting agent

Gently agitate the washed film, still on the reel, in a properly diluted solution of wetting agent such as KODAK PHOTO-FLO Solution for 30 seconds. The wetting agent allows the film to drip-dry cleanly, free of water spots.

You can speed drying by removing excess diluted wetting agent from film. After you hang the film, drench your fingers in diluted wetting agent. Then squeegee the film gently between your fingers. Very light pressure works best.

CUTTING AND STORING FILM

Check that film is dry by running your fingertips lightly along both edges. If the film glides smoothly without feeling tacky, it is dry enough to handle. With 35 mm film, also run your fingertips lightly over the sprocket holes, which tend to retain water droplets. Don't take the film down until the sprocket holes are thoroughly dry.

Handling the dry film by the edges, cut it into shorter strips. For convenience in proofing the film later, cut it into lengths of negatives that will fit within the length or width of the photographic paper you use for proof printing. For example, a 36-exposure roll of 35 mm film can be cut into six strips of six negatives each and proofed on a single 8 x 10-inch *20.3 x 25.4 cm* sheet, although it's a tight squeeze.

Each negative strip should be placed in a sleeve or envelope made specifically for photographic use. Paper and synthetic materials not intended for photographic applications may contain chemicals that accelerate deterioration of photographic images.

Negatives should be stored in a cool, dry area. High heat and humidity impair the normally excellent longevity of properly processed black-and-white negatives.

For easy handling and filing, cut your dry, processed negatives into strips. Then place each strip into a separate sleeve or envelope specially made for photographic materials.

FILING NEGATIVES

If you are an active photographer, you will eventually accumulate enough negatives to benefit from a simple filing system that will allow you to find specific negatives without a struggle. One workable system is based on assigning each roll of film a number consisting of three groups of digits: the last two digits of the year; one or more digits identifying the month; and one or more digits indicating the sequence of the roll in the month's shooting. The fourth roll of film exposed in March, 1981, would thus be identified as *81-3-4.* A particular negative, and any print made from it, would be identified by the roll number plus the film edge number of the frame. A print made from the sixth negative on the roll in this example would be marked *81-3-4-6.*

In roll sequence, store the negatives in appropriately marked envelopes or sleeves. Mark roll numbers on the backs of proof sheets. Mark roll and frame numbers on the backs of enlargements. Now you'll be able to find any negative easily. If you need a subject or location file, a card index or loose-leaf notebook can work neatly with a numbering system. Naturally, proof sheets should also be kept in sequence, in a file or ring binder.

For maximum life of negatives, follow the processing recommendations very closely. You can store your negatives at normal room temperature, such as 60 to 80°F *16 to 27°C.* Keep them where it's dry, below 60 percent relative humidity, to avoid the possibility of mold or fungus growth. Since the silver image may be attacked by certain sulfur compounds, protect your negatives from fumes of hydrogen sulfide and coal gas.

Your negatives will stay clean and unharmed when you file them properly. A ring binder makes a good compartment for organized storage of both negatives and proof sheets. (See page 29.)

TROUBLESHOOTING

Clear pinhole dots: Air bubbles adhered to the film emulsion, preventing developer contact. Rap tank sharply several times to dislodge air bubbles at the start of development.

Dark crescent marks: Crimp marks caused by rough handling that buckled the film sharply before development.

Lengthwise scratches: Dirt or grit in camera, on 35 mm magazine feed lips, or on fingers or sponge when removing excess wetting agent solution.

Stain and chemical deposits: Usually result from inadequate washing and/or overly strong solution of wetting agent. Rewashing and drying properly may help.

Free-form streaks and splotches: Water marks caused by accidentally rewetting small areas of dried emulsion. May also be caused by water drops remaining on film during drying, a common problem when a wetting agent is not used.

Particles imbedded in emulsion: Dirt or dust in drying area settled on the wet or damp emulsion. Rewashing and drying in a clean area may help.

Completely clear film: Fixer was poured into the tank first, instead of developer. Label containers prominently to avoid mix-ups.

Static electricity : Marks on film caused by static electricity discharges. When handling unprocessed film, avoid sudden movements, such as rapid rewinding, that might cause friction. Also, peel tape from film ends slowly, especially in a dry environment.

Irregularly shaped blotches: Film buckled out of guide channels in the reel, and contact between adjacent surfaces prevented uniform processing.

Overall gray veil: Film was fogged, probably by light leaking into the darkroom during the tank-loading step.

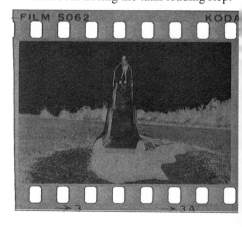

Clear image area with only edge identification present: Film was developed but received no exposure in the camera. Check camera loading procedures and/or shutter operation.

Excessive density: **Overexposed**

Harsh-looking, dense negatives:
Overdeveloped because of improperly diluted developer, too long developing time, too high processing temperature, excessive agitation, or a combination of these faults.
 Also can be caused by overexposure.

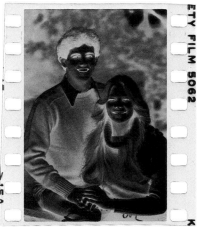

Excessive density: **Overdeveloped**

Excessive graininess: May be caused by severe overexposure and/or overdevelopment. Sharp fluctuations in processing temperature can also cause emulsion reticulation that resembles excessive graininess.

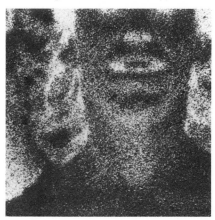

Lengthwise streaks: A portion of the film was improperly developed or fixed because the solution level in the tank was too low to cover the reel completely.

Weak-looking, thin negatives:
Underdeveloped because of overworked developer, overage or dilute developer, too short developing time, too low processing temperature, insufficient agitation, or a combination of these faults.
 Also can be caused by underexposure.

Lack of contrast: **Underexposed**

Lack of contrast: **Underdeveloped**

Making proof sheets

Carefully made proof sheets are invaluable photographic aids. Besides their obvious utility in providing easy-to-view records of many pictures at a glance for picture selection and filing, they can help you choose the best negatives for enlarging and furnish useful clues about how to enlarge each frame. The time you spend making good proof sheets will be saved several times over when you make enlargements.

Proof sheets, also called contact sheets or contact prints, are sheets of photographic paper presenting positive, tonally correct images of the negatives from a whole or part of a roll of film. Each positive on a contact sheet is the same size as the negative from which it was made. Remember that your negatives won't all have the same density, so some of the individual prints on the proof sheet will be darker than others.

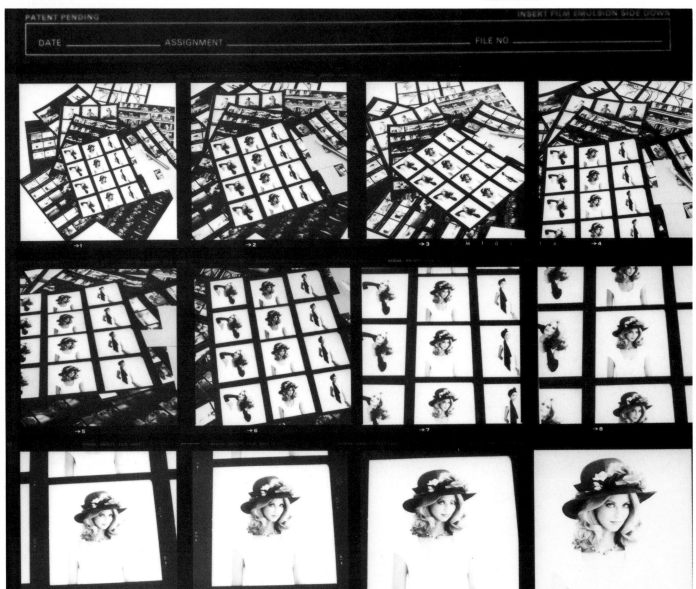

READ DATA SHEETS AND INSTRUCTIONS

Your enlarger, which will serve as an easily regulated light source for exposing proof sheets, is the most complex apparatus involved in proofing. Read the owner's manual carefully before beginning to work. Be sure that the recommended enlarging lamp has been installed. If you have more than one enlarging lens, check that the correct one for the film size that you are using is mounted. Place a negative carrier of the proper size for the film format in the enlarger head.

Following manufacturer's instructions, connect the enlarger power cord to the proper outlet of your darkroom timer, and connect the timer to a source of suitable line current. You will be able to use the timer as a switch to control the enlarger light at will, and the timer will also turn the enlarger on to start exposure and turn it off automatically when the preset time has elapsed.

Check the data sheet supplied with your enlarging paper to find out what darkroom safelight the manufacturer suggests. Most KODAK general-purpose enlarging papers can be handled under light from the KODAK Safelight Filter OC (light amber). Also check that a bulb of the correct size and wattage is in the safelight. The safelight should be placed at a distance of no less than 4 feet *1.2 metres* from areas where you will be handling enlarging paper.

THINGS YOU'LL NEED

1. Darkroom or work area that can be darkened
2. Contact frame
3. Enlarger with negative carrier and lens appropriate to the film size
4. 8 x 10-inch *20.3 x 25.4 cm* photographic paper of the same type you will use for enlarging, in various contrast grades or, for selective contrast papers, with a set of suitable contrast control filters. *See the chapter on photographic papers.*

5. Darkroom safelight
6. Darkroom timer (the same one used for timing film processing)
7. Masking tape
8. Equipment and supplies itemized in the applicable 'Things you'll need' list on page 59 in the chapter on print processing.

A darkroom safelight provides enough illumination to see what you are doing while printing. The light doesn't affect the printing paper because it is composed of wavelengths to which the paper emulsion is insensitive.

CHECKING DARKROOM AND SAFELIGHT INTEGRITY

The same check for darkness suggested in the first chapter should be repeated in the darkened area used for printing. Although photographic paper is less sensitive to light than film, printing procedures require exposing paper to the darkroom environment for comparatively long periods of time. To avoid degrading print quality through cumulative low-level exposure, be as careful about handling paper as you are about film.

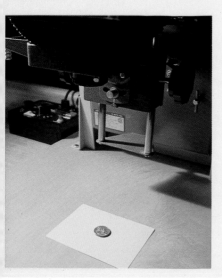

It is also important to check the safety of your darkroom safelight, particularly if the filter has been used for some time. Filters can fade with age, becoming less safe as they do.

An easy safelight test, **left,** consists of exposing a small piece of your usual enlarging paper under the enlarger just long enough to create an even, very pale gray tone when the paper is processed normally. You'll probably have to close the enlarger lens to its smallest opening and use a very short exposure time. When you have determined the proper exposure experimentally, expose (flash) a piece of paper at those settings; then place a coin on the center of it. Leave the coin and paper where they are beneath the enlarger for 5 minutes, *with the safelight on.* Process the paper normally. The processed sheet should look the same as the one processed immediately following exposure. If you can spot even a faint outline of the coin, the safelight isn't safe.

If all is well in the enlarger area, repeat the test by placing flashed paper and a coin in the processing area, **above right,** for 5 minutes, preferably just above the developer tray. If no image of the coin materializes, the safelight is adequately safe.

When the test piece of paper, *below,* is processed normally, it should show an even light-gray tone (left), signifying that the safelight is actually safe for paper handled in the vicinity of the enlarger. If the processed test piece shows a lighter tone where the coin rested (right), the safelight is fogging the paper. Check the bulb and filter, and replace if necessary. Also check the distance from safelight to work surface; it may be too close.

ADJUSTING THE ENLARGER

Place the contact frame onto the enlarger baseboard and turn on the enlarger. Turn off the room lights. Raise the enlarger head until it casts a pool of light large enough to cover the contact frame with room to spare around the edges. Adjust the focus until the edges of the empty negative carrier cast a sharply defined shadow, **below,** outlining the lighted area of the baseboard.

It may be necessary to readjust the enlarger height and refocus several times before you have a sharp-edged patch of light extending a few inches beyond the edges of the contact frame. Note the actual height of the enlarger head above the baseboard. Measure the distance, **below,** or read it from the calibrated column, if your enlarger has one.

Whenever you make proof sheets, adjust the enlarger the same way.

Raising the enlarger head to a uniform distance from the baseboard each time you expose contact sheets automatically establishes a consistent light intensity, making it easier to determine exposure.

Outline the lighted area, **above,** with strips of masking tape that contrast with the tone of the baseboard. When the enlarger is turned off, these strips of tape will indicate where to place the contact frame. Turn off the enlarger and turn on the room lights.

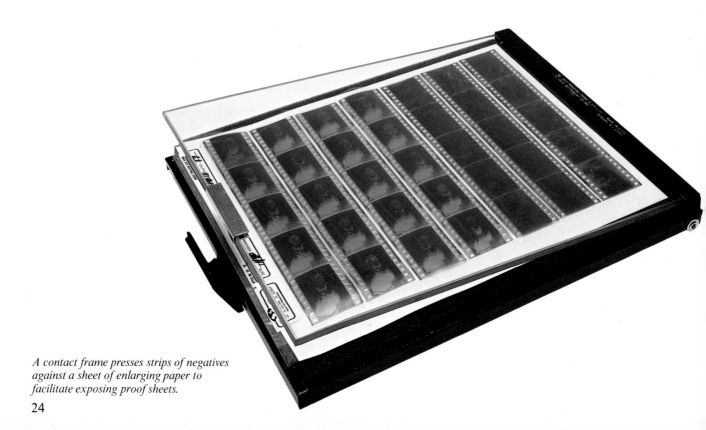

A contact frame presses strips of negatives against a sheet of enlarging paper to facilitate exposing proof sheets.

PREPARING THE CONTACT FRAME

A contact frame is a device for pressing strips of negatives firmly against a sheet of photographic paper. Commercially made contact frames often consist of a rectangle of glass or clear plastic hinged at one end to a rigid base, with a catch to hold them together. Some types have alignment grooves or clips to position strips of negatives precisely; others do not. Both usually accept 8 x 10-inch *20.3 x 25.4 cm* photographic paper.

In room light, inspect the negatives and, if necessary, gently blow away any dust or lint that may have settled on

them. Handle the strips of film by the edges to avoid finger-marking the picture area. Inspect the transparent plate of the negative frame, and remove dust or fingerprints by wiping it gently with a soft, clean, lint-free cloth. If the contact frame is designed to take negatives first and then paper, arrange the strips of film in order according to the directions furnished with the contact frame. Make certain that the emulsion (dull) side of the film will be facing the photographic paper, or your proofs will be reversed.

If your negative strips are in transparent, polyethylene sleeves that are designed for photographic use, you may not need to remove the strips for making the proof sheet. If your print frame can handle a variety of negative sizes, it will probably accept these sleeves. By proofing through a sleeve, you keep your negatives cleaner since you won't be touching them as often.

When you are ready to load the paper, turn off the room lights and turn on the darkroom safelight. Remove a sheet of normal-contrast paper from its envelope or box, handling the paper by the edges. Close the paper container

completely and carefully. Write the negative roll number lightly on the back of the paper with a ball-point pen. Place the sheet in the contact frame with the emulsion facing the negative emulsion. The emulsion side of the paper looks shinier than the back of the sheet and glints under the safelight. Latch the frame shut to clamp the negatives and paper together.

Contact frames designed to take the paper first, then the negatives, must be loaded under safelight illumination from the start.

IMPROVISING A FRAME

For occasional use, you can improvise a contact frame by placing a sheet of photographic paper, emulsion up, on the enlarger baseboard within the tape markings. Arrange your negatives emulsion down on the paper. Then on top lay a sheet of plate glass cut slightly larger than the paper size to hold the negatives firmly against the paper. Avoid cuts by removing the sharp edges of the glass with carborundum sandpaper, or by taping the edges.

Before exposing the sheet, check again (under safelight illumination) that the film is in place neatly and that the strips are correctly oriented. It can be irritating to keep turning a contact sheet because some pictures are upside down as a result of careless negative positioning.

Check that an enlarging lens of the correct focal length for the film format is in the enlarger. The focal length is often marked on a retaining ring surrounding the front element of the lens, as shown here. Or it may be marked on the lens barrel. Consult the enlarger owner's manual or see the table **at right** *if you are unsure what lens focal length to use.*

Normal enlarging-lens focal lengths for various film sizes

Film size	Lens focal length
Subminiature	25 mm
110	25 mm
Half-frame 35 mm *18 x 24 mm*	30 mm
126	40 mm
135	50 mm
127 *4 x 4 cm*	60 mm
120 *6 x 6 cm*	75 mm
120 *6 x 7 cm*	90 mm
2¼ x 3¼ in. *6 x 8.3 cm*	105 mm
4 x 5 in. *10 x 12.7 cm*	150 mm

Longer-than-normal focal-length lenses yield less magnification at any given enlarger height. Shorter-than-normal focal lengths may not give complete or even image coverage on the easel.

SETTING THE ENLARGING LENS AND TIMER

If you have adjusted the enlarger height, as described on the previous page, its head is now at approximately the height required to make an 8 x 10-inch enlargement from a negative similar to those you are proofing. Use the same paper for proofing as for enlarging. Set the lens to the same aperture you normally use when making 8 x 10-inch enlargements, and set the timer for the same exposure time you would use to expose such enlargements. Following these procedures will normally yield a contact sheet that is at least close to the required exposure.

If you haven't yet gained enough darkroom experience to have a standard enlarging exposure from which to improvise, make your first contact sheet with the lens set at $f/8$ and the timer set for a 10-second exposure. You have to start somewhere, so it may as well be here.

Make sure the contact frame is face up within the area that will be illuminated, and begin the exposure. When the exposure ends, remove the paper from the contact frame.

PROCESSING THE PROOF SHEET

Proof sheets are processed in exactly the same manner as an enlargement or a print. *See pages 63-65 for recommended procedures.*

After fixing for 30 seconds or longer, you can turn on the room lights. Before doing so, it's a good idea to double check that the paper envelope or box still housing unexposed paper *is properly closed.*

*If a proof sheet is too dark overall, as at **left,** it is overexposed. Reducing the exposure time appropriately results in a properly exposed contact sheet.*

*A proof sheet that is too light overall, **below,** has been underexposed. Reprint it for a longer time to produce a correctly exposed contact sheet.*

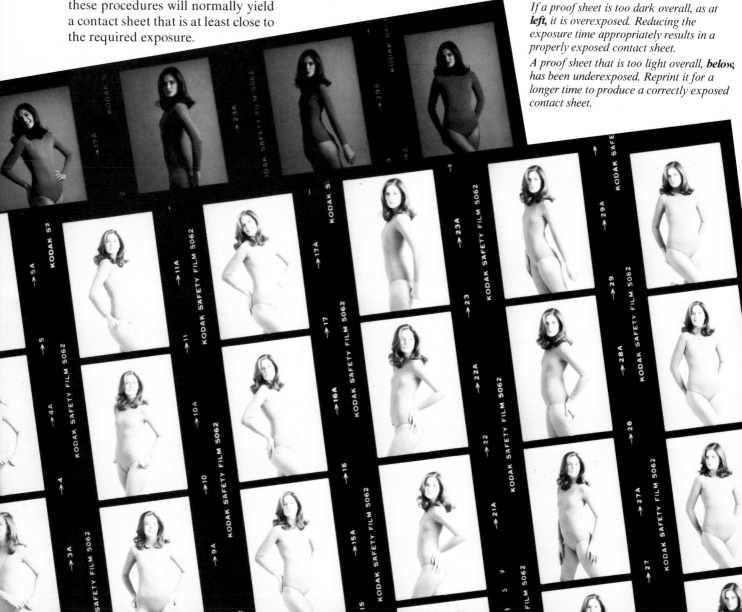

EVALUATING EXPOSURE

A proof sheet should be a collection of good miniature prints, assuming that the negatives themselves are of good quality. If most of the individual pictures are too dark, make another proof sheet exposed for a shorter time. If most of the pictures look too light, make another proof sheet exposed for a longer time. The easiest way to estimate the correct exposure time is to look at the pictures and ask yourself what percent lighter or darker you would like the proof to be. To be perceptible, the exposure change should be 20 percent or more.

If you want the pictures to look 50 percent darker, increase the exposure time 50 percent. If you want them to look 50 percent lighter, decrease the exposure by half. Don't expect all the frames on a roll of film to be rendered

identically. Set exposure for the contact sheet to a preponderance of representative frames. If a few important strips of film or individual negatives are so over- or underexposed relative to the rest of the roll that no useful images result, proof them separately on smaller strips or sections cut from a sheet of photographic paper. Then staple the small corrected proofs in place on the master proof sheet.

Note on the back of the proof sheet the exposure settings used to make it. Later, if you make an 8 x 10-inch enlargement of a typical negative from the roll, the same exposure that produced a good contact print will be a good starting point for exposing a test strip or trial print.

EVALUATING CONTRAST

If most of the frames on a proof sheet look dull and gray, make another proof of higher contrast. Select a higher contrast grade of paper or place a higher contrast filter in the enlarger. If a majority of pictures on a contact sheet are excessively contrasty, with glaring highlights and intense shadows, but few middletones, reproof the roll on a lower contrast paper grade or use a lower

contrast filter in the enlarger. It may be necessary to change the exposure time when changing contrast because of variations in paper sensitivity at different contrast levels. The data sheet supplied with Kodak enlarging papers provides necessary information about paper speeds as they relate to contrast. Note the exposure time and contrast grade with a ball-point pen on the back of the sheet of enlarging paper before processing it, along with the roll number.

Variations in contrast within a roll of film are rarely so severe as to require stapling the contrast corrected strips to the master proof. Even frames that are much too contrasty or flat usually yield enough information in contact form for subject identification, editing, and subsequent enlarging.

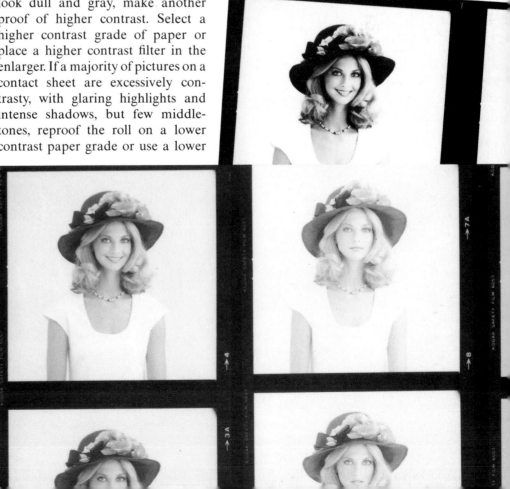

*A flat, grayish contact sheet, **right,** deficient in contrast, should be reprinted on a higher contrast grade of paper (or with a higher contrast control filter) to produce a contact sheet that looks normal.*

*An excessively contrasty contact sheet, **far right above,** with harsh, paper-white highlights, inky black shadows, and few intermediate tones can be improved by reprinting on a less contrasty paper or with a softer contrast control filter.*

If part of a roll of film is too under- or overexposed to print acceptably compared to the rest of the negatives, contact-print that part on separate strips of paper at whatever exposure produces useful images. Staple or tape the corrected strips to the master contact sheet for the roll. Note your exposure data for both groups of negatives.

SELECTING PICTURES FROM A PROOF SHEET

Although the pictures on a proof sheet are small, a glance is usually enough to spot those that are the most appealing candidates for enlargement. However, final selection should be done by inspecting each frame carefully with a good-quality magnifier or loupe, such as the KODAK Achromatic Magnifier, 5X. Only with magnification can you verify that one frame is, indeed, sharper than a similar one next to it, or that someone's eyes are fully open rather than squinting against the sun. The magnified view is as close to looking at an enlargement as you can come without actually making the enlargement.

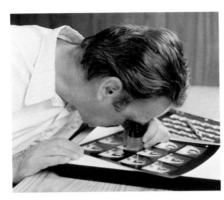

Unless you have a compelling reason to do otherwise, select for enlargement only frames that are well composed, well exposed, properly focused, and adequately sharp. Note the frame numbers of the negatives you wish to print.

Select pictures for printing after examining individual frames with a good magnifier or loupe, such as the KODAK Achromatic Magnifier, 5X. Magnification reveals details that are not apparent to the unaided eye but that may be very apparent in an enlargement.

Cropping on the proof sheet

Many pictures can be improved by tightening the composition through cropping. Eliminating extraneous detail directs the viewer's attention more strongly to the subject of prime interest. You can save time when enlarging by planning your cropping ahead of time and indicating it on the proof sheet.

When you pick a picture on a proof sheet for enlargement, ask yourself if it is framed exactly as you wish to print it, or if some cropping would improve it. To preview the effect of cropping, cut two L-shaped pieces of white cardboard and use them as continuously adjustable substitute borders for changing the size and proportions of the image area. You can achieve the same effect, although less conveniently, by surrounding the frame with four index cards. Move them individually in and out to alter framing.

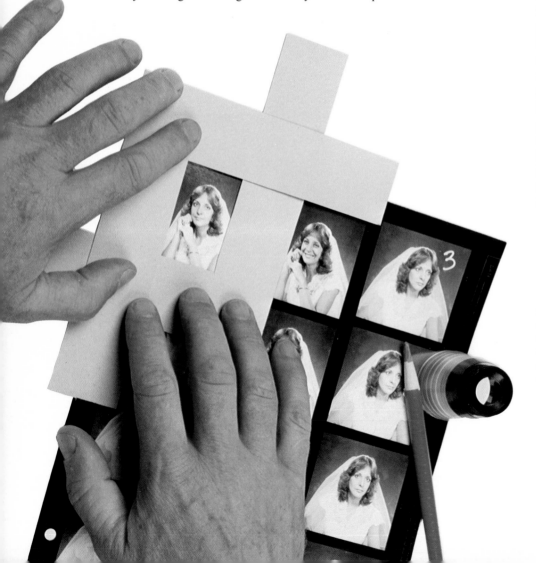

Two L-shaped pieces cut from white card stock are useful for previewing the effect of cropping a picture. Hold the Ls over the contact sheet so that each forms two edges of a continuously adjustable frame. Move the Ls relative to each other and the picture to determine the best cropping.

When you've settled on the best framing, use a china marker (grease pencil) or a permanent-ink marking pen to indicate directly on the proof sheet the cropping you prefer. If you make a mistake or change your mind, you can remove the traces of china marker by rubbing the surface of the print gently with a tuft of cotton.

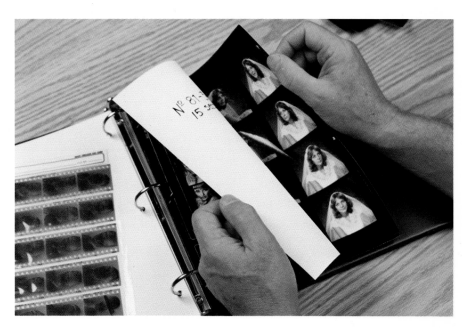

A ring binder is convenient for filing contact sheets. It keeps them in order while permitting easy access.

FILING PROOF SHEETS

File proof sheets as carefully as negatives, keeping them in order of roll number for easy retrieval. Depending on your personal tastes and needs, you can store proof sheets in file drawers or boxes, or in ring binders. Whichever method you choose, keep the sheets in a dry area that doesn't experience leaps and dips in temperature and relative humidity, and that is free of chemical fumes. Properly processed black-and-white photographic paper can last a long time, given proper storage conditions.

Enlarging

Making black-and-white enlargements from your negatives can be even more pleasant and rewarding than taking the pictures in the first place. Under the darkroom safelight, you can see what is happening as it happens. If you're not satisfied with a print you've just made, you can decide what needs changing and make a new and improved version on the spot. Many photographers find, too, that doing their own printing spurs them to become more accomplished photographers, because it is easier to make first-rate prints from first-rate negatives. Printing well is a major creative component of the photographic process.

READ DATA SHEETS AND INSTRUCTIONS
Before starting an enlarging session, review data sheets and instruction manuals for all supplies and equipment you'll be using. This is particularly important if you use several different types of enlarging paper. Not all papers are compatible with the same safelight filter or, in some cases, with the same developer. It's better to find out, or be reminded, in time to avoid potential problems.

If you haven't yet used them, familiarize yourself in room light at your leisure with your enlarging easel and focusing aid. Although both are inherently simple devices, it's sometimes amazing how complex simple devices can become the first time you try to use them under darkroom conditions.

THINGS YOU'LL NEED
1. Enlarging easel
2. Focusing aid
3. Can of compressed air
4. Camel's-hair brush
5. Everything listed under '*Things you'll need,*' page 23, except the contact frame

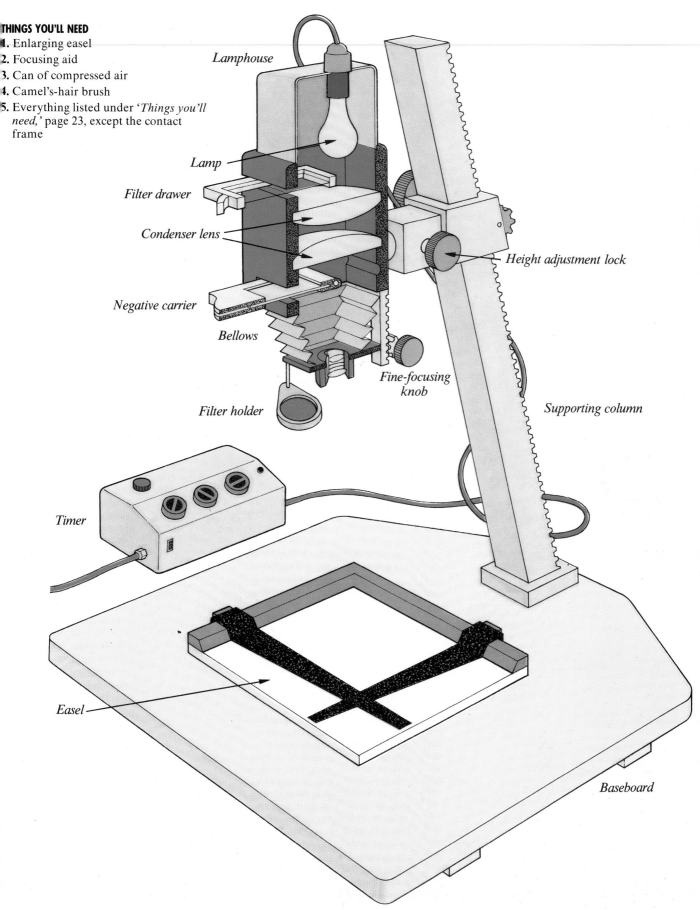

Lamphouse

Lamp

Filter drawer

Condenser lens

Negative carrier

Bellows

Filter holder

Fine-focusing knob

Height adjustment lock

Supporting column

Timer

Easel

Baseboard

Enlarging easels are available in simple, single-size models with fixed borders and more elaborate styles with adjustable masking bands.

Enlarger focusing aids provide a magnified view of a portion of the projected image to help you focus more accurately than you can with your unaided eye.

Cans of compressed air sold for photographic use are handy for blowing dust from negatives and enlarging equipment. A clean camel's-hair brush helps dislodge particles that don't blow away. When blowing dust from a negative with compressed air, keep the air can far enough from the negative so that no part of the can or nozzle touches it. If the can has a removable plastic air tube, glue or tape it to the main nozzle so that it cannot blow off toward the negative.

CLEANING THE NEGATIVE AND CARRIER

Handling the strip of negatives by the edges, blow dust from the emulsion (dull) side and base (shiny) side of the frame you wish to print, using short blasts of air from a can of compressed air. Examine both sides critically. If any stubborn specks of dust remain, remove them by brushing slowly with the camel's-hair brush. Keep the air can and brush handy because this is just a preliminary cleaning.

Rest the strip of negatives emulsion down on a clean piece of paper while you blow and brush dust from all surfaces of your enlarger's negative carrier. If you use a glass-sandwich negative carrier, which holds the negative between two plates of glass, all four glass surfaces must be cleaned. If spots or fingerprints remain on the glass

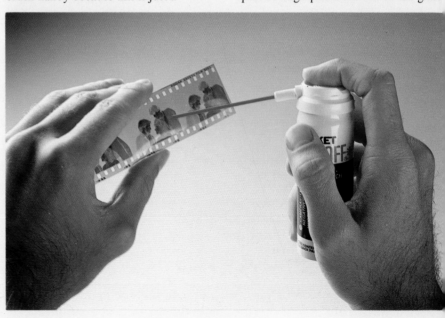

*Position the strip of negatives in the carrier, **above,** so that when the carrier is placed in the enlarger, the negative emulsion (dull) side will be facing down, toward the easel. Also, orient the frame you are enlarging so that the enlarger will project a right-side-up image, **right.** Placing the negative in the carrier with the scene upside down results in right-side-up projection.*

surfaces, clean them with KODAK Lens Cleaner and KODAK Lens Cleaning Paper. Dry the surfaces thoroughly with more lens tissue before inserting the strip of negatives. Simple wiping or brushing is normally all the cleaning a glassless negative carrier requires.

Despite the need for constant, careful cleaning, glass carriers are preferable when making extremely great enlargements, when very long exposure times are required, or with negatives that refuse to lie reasonably flat in a glassless carrier. Glassless carriers demand less attention and are therefore preferable for routine use.

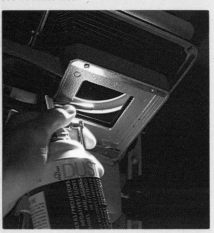

CLEANING THE LAMP HEAD

Before sliding the negative carrier into the enlarger, turn off the room lights and turn on the enlarger lamp. Open the negative stage enough to look up at the bottom surface of the lamp head. If it looks dusty, blow it clean with a jet of air, **left.**

As a last check for dust, hold the negative carrier obliquely in the beam of light from the enlarger, with the light skimming each surface of the negative in turn, **above.**

Remove any dust specks you find, and place the carrier in the enlarger. The reason for devoting so much time to dust removal is that dust on the negative casts shadows on the enlarging paper during the exposure. The shadows record as enlarged light or white specks. They can be concealed in the finished picture by print spotting (*see page 85*), but it takes far less time and effort to remove the dust from the negative than to remove the spots from the print.

33

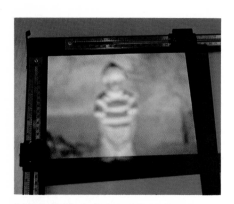 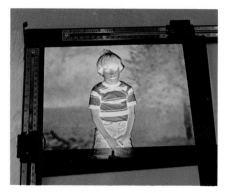 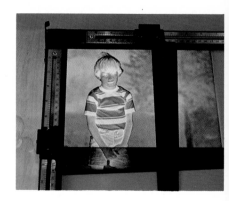

COMPOSING AND ROUGH FOCUSING

With room lights off and the enlarger lamp on, adjust the height of the enlarger head until an image of approximately the desired size is projected on the enlarging easel. Open the enlarging lens to full aperture for maximum image brightness. Adjust the focus until the image looks sharp. It will change size somewhat as you focus. Readjust the height of the enlarger head until the picture area you wish to print falls again within the masking bands or borders of the easel. Refocus the image. It may be necessary to alternate height and focus adjustments several times to arrive at the exact image size and/or cropping you want.

If the desired image area doesn't conform to standard paper dimensions, fit the longer dimension of the image to the longer paper dimension as far as possible. If your easel has adjustable borders, you can move the masking bands as necessary to enclose the desired picture area neatly. With a nonadjustable easel, trim the print to achieve final cropping.

Fine focusing

When no further size adjustments are needed, fine-focus the image for maximum sharpness. Place face down on the easel a discarded print made on the same thickness enlarging paper you are currently using. Center the focusing aid on it and slowly adjust the focus until the image appears sharpest through the

*Raise or lower the enlarger head as necessary until the projected image is approximately the right size, **left**.*
*Focus the enlarger until the image looks sharp, **above**. Focusing may change the size of the projected image enough to require readjusting the enlarger height.*
*If you have an adjustable easel, you can also crop the projected image, **right**, as you wish by moving the masking bands until they enclose exactly the portion of the image you wish to print.*

focusing aid. Some focusing aids magnify the image strongly enough to permit focusing on the grain of the negative. Others require focusing on a small image detail. Follow the manufacturer's instructions.

Check focus at the corners and edges of the easel as well as in the center. If the corners and edges appear noticeably less sharp than the center, stop the enlarging lens down to a smaller aperture to increase the depth of focus. At this point, sharpness should be even across the paper surface.

*For maximum focusing accuracy, **below**, place a sheet of old enlarging paper or a discarded print in the easel before fine-focusing with the focusing aid. After focusing, close the lens diaphram until the center and edges of the image look sharp through the focusing aid.*

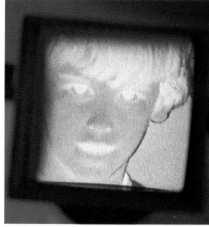

If there is still a significant difference in sharpness between the center and the edges of the projected image, reopen the lens to the full aperture. Place the focusing aid approximately midway between the center and a corner of the easel, and focus again. Stop the lens down to the aperture you wish to use and recheck the focus at center and edges. Sharpness should now be uniform. If minor discrepancies remain, close the lens to a smaller aperture to increase further the depth of focus. Turn the enlarger lamp off.

81-10-3
15 sec. F/8

An underexposed negative requires a shorter-than-normal printing exposure.

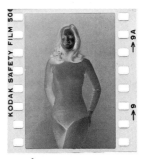

Negative with normal exposure.

An overexposed negative requires a longer-than-normal printing exposure.

The same exposure settings that yielded a properly exposed proof sheet will be approximately correct for a trial exposure of a negative from that set, if you enlarge onto similar paper and blow up the image to about the dimensions of the proof sheet.

CALCULATING EXPOSURE

When making an 8 x 10-inch *(20.3 x 25.4 cm)* enlargement from a negative you proofed as described on pages 24–26, the same lens setting and exposure time that yielded a good proof sheet will produce a useful trial print or test strip on the same type of paper.

If, to achieve overall sharpness, you closed the enlarging lens to a smaller aperture than that used when proofing, you must adjust the exposure time accordingly to maintain the same exposure. Double the exposure time for each smaller *f*-stop setting. For example, if you made a good proof print at *f*/8 with a 10-second exposure, but have now closed the lens to *f*/11 (one stop smaller), double the exposure time to 20 seconds.

If you don't know what the exposure was for the contact sheet, set the lens and timer to values that have produced good results for you when printing from similar negatives in the past.

As a last resort, arbitrarily set the lens to *f*/8 and the timer for a 10-second exposure if the negative looks fairly normal. If it looks somewhat thin, set the timer for 7 seconds. If it looks heavy (slightly overexposed or overdeveloped), set the timer for about 15 seconds.

Don't be disturbed about failing to be exact when estimating print exposure. Even highly experienced darkroom workers don't expect to make an excellent print on the first try.

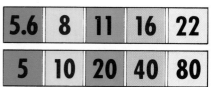

5.6	8	11	16	22
5	10	20	40	80

*In the table **above,** f stops are on top with typical corresponding exposure times (seconds) on the bottom. Note how full-stop changes double or halve the exposure time. For example, f/8 at 10 seconds produces an exposure equivalent to f/11 at 20 seconds.*

35

ESTIMATING PAPER CONTRAST

Most properly exposed and processed black-and-white negatives of normal subjects print comfortably on paper of normal contrast. Unless it is unmistakably obvious that a negative is extremely flat or contrasty, select a paper of normal contrast grade (or a normal-grade contrast filter) for the trial print or test strip. If a negative is clearly too contrasty, choose a softer (lower) paper contrast. If a negative is too flat, select a higher-than-normal paper contrast.

A negative of normal contrast will print correctly on a paper of normal contrast.

You can make a normal-looking print from an overly contrasty negative by enlarging it onto a paper of lower-than-normal contrast.

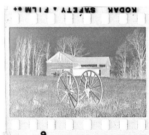

You can also make a normal-looking print from a flat negative (one that lacks contrast) by enlarging it onto a paper of higher-than-normal contrast.

TEST PRINTS AND STRIPS

Test prints and strips are the same except for size. A test print is a sheet of photographic paper exposed and processed to find out if your exposure and contrast estimates are correct. Occasionally, you will be lucky enough to make a test print that looks good enough to be the final print. Don't be disappointed if it doesn't happen often.

A test strip is a 1- or 2-inch-wide *(25 or 50 mm wide)* strip of enlarging paper cut from a larger sheet. Since a single sheet yields 5 to 10 usable size test strips, it is clearly more economical to expose test strips rather than

full test prints. On the other hand, you must be careful to place test strips so that they record a representative sample of image tones.

Darkroom workers who prefer test prints argue that the greater expenditure of materials is balanced by the advantage of being able to appraise the entire picture, rather than a narrow strip.

As a practical compromise, expose a full test print when a picture contains randomly distributed tonal variations, and use test strips with more similar toned images.

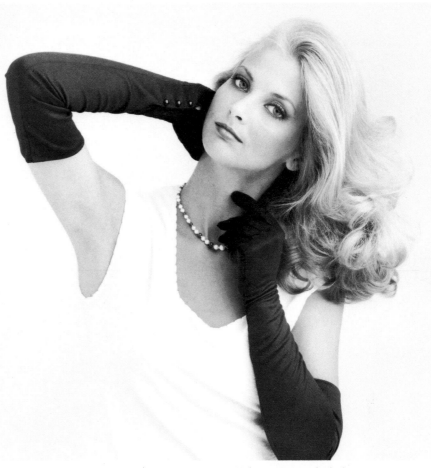

*You can cut a single sheet of enlarging paper, **left**, into a half dozen or more economical test strips for use in determining the best print exposure.*

*With pictures in which the most important image tones are prominent and fairly close together, **above**, a strategically placed test strip can provide all the exposure information you need. Position the test strip to sample well-lighted, representative skin tones, **below**.*

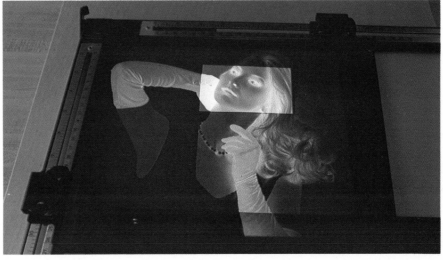

MAKING A TEST EXPOSURE

Remove a sheet of suitable enlarging paper or a test strip from its lighttight envelope or box, and close the container completely. With a ball-point pen or china marker, note on the back of the paper the negative file number, lens aperture, and exposure time.

Open the easel, remove the focusing paper, and insert the test material, emulsion side up. If you're using a test strip, place it where it will record a tonally significant portion of the subject. For pictures of people, position the test strip to record representative skin tones. For landscapes and general subjects, sample significant terrain or other features. If necessary, use two or three test strips or one very long one to sample different areas

simultaneously. Close the easel to hold the paper flat.

Wait a few seconds until any enlarger vibration that may have been generated by your movement has dissipated; then begin the exposure. When the exposure ends, remove the test print or strip from the easel.

Process the test as described on pages 63–65.

*When a picture contains a random distribution of widely varying and widely separated tonal areas, **left,** a test print of the entire image makes it easier to estimate a correct final exposure than the more limited tone sampling provided by a single test strip. Or, to conserve paper, you can place two or more test strips in divergent tonal areas, **above.***

*Drain excessive fixer from a test print
before evaluating it. Wet prints tend to look
lighter and brighter than they will look
when merely damp or when dry.*

*If the print looks gray and muddy because
of insufficient contrast, reprint it on a
harder, more contrasty grade of paper.*

EVALUATING THE TEST

When the test print or strip has been in the fixer for 30 to 60 seconds, turn on the room lights and examine it. If the print is wet with fixer, as in tray processing, place it in a clean, dry tray and hold it almost vertically above the fixer tray to drain.

Look at the image and ask yourself if you would prefer the final print to be lighter or darker overall. If so, by what percentage? If you are evaluating a wet print, consider that most enlarging papers dry down; that is, they generally look slightly darker and have less shadow detail when dry than they do when wet. Different papers vary markedly in this respect, so experience with a particular product is your best guide to how much to allow for drying down.

Next, decide if the tonal relationships within the picture are reasonable. Does the print have clean whites and deep blacks? Is there enough detail and texture in important highlight and shadow areas? Are people's skin tones rendered in appropriate shades of gray? If the picture looks too harsh overall, reduce the paper contrast. If it looks too flat and muddy, increase the paper contrast. In any event, don't attempt to judge contrast from a grossly over- or underexposed test print or strip. Make a reasonably exposed test first, then correct the contrast afterward.

If you made a full test print, decide if further cropping is in order. And check the print for defects such as fingerprints or large dust spots. It is better to spend a couple of minutes cleaning the negative rather than 30 minutes later on spotting the print.

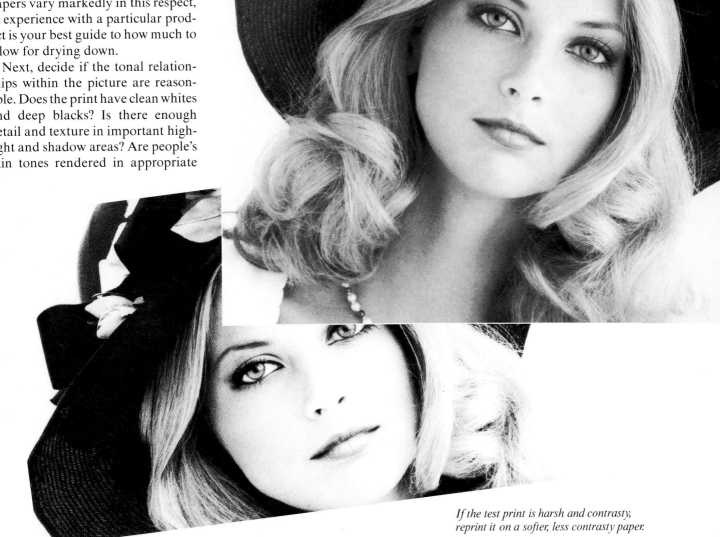

*If the test print is harsh and contrasty,
reprint it on a softer, less contrasty paper.*

FINAL EXPOSURE CORRECTION

If you aren't altering print contrast or image size, set the corrected exposure time on the timer now. If you are switching paper grades or contrast-control filters, though, you may have to calculate a further exposure correction. Most enlarging papers are not uniformly light-sensitive in all contrast grades. Relative speeds of Kodak enlarging papers at different contrast levels are presented in the data sheets packed with the products, and are also published in the *KODAK Complete Darkroom DATAGUIDE* (R-18). Exposure adjustments needed to compensate for changing image size, or magnification, are most easily determined with the *Enlarging Dial* circular slide rule included in the *DATAGUIDE*. The larger the image, the more exposure is required; the smaller the image, the less exposure is needed to produce a print of a given density.

If comparatively minor exposure change is indicated, you can proceed with making a full-sheet final print. If you have to make a major adjustment based on juggling several variables, you should expose another test strip before committing a full sheet. With a little experience and a methodical approach, you will seldom need more than two tests to obtain a well-exposed enlargement from a good negative.

When you are ready to make the final print, before putting the enlarging paper in the easel, write the negative number, exposure time, lens aperture, and contrast grade on the back. If you wish to duplicate the print at a later date, you won't have to repeat the entire series of tests and calculations.

*The **Enlarging Dial** included in the **KODAK Complete Darkroom DATAGUIDE** is a multipurpose, circular slide rule that makes it easy to calculate new exposure times required when changing image magnification.*

USING A SHORT-FOCAL-LENGTH LENS

An enlarging lens with a focal length shorter (numerically lower in focal length) than that considered normal for the size negative you are enlarging will produce greater image magnification for a given enlarger height than the usual lens. But it will usually not cover the entire negative evenly. Any short-focal-length enlarging lens you select for such use should be capable of projecting an evenly illuminated image of the entire negative, unless you intend using it only to enlarge small segments of the frame.

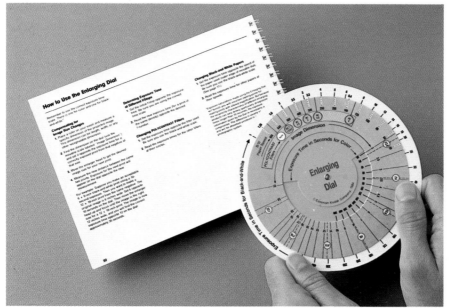

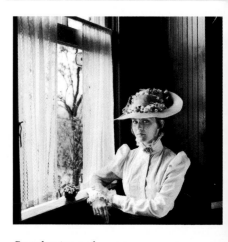

*By enlarging and cropping, you can transform an overall view that was recorded in a square format, **above**, into a horizontal or vertical presentation, **opposite page.***

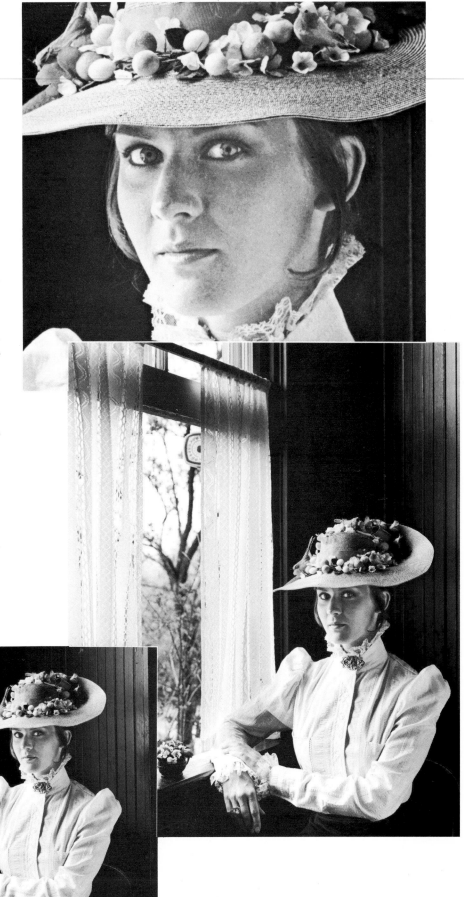

You don't have to make a big print to benefit from the techniques of extreme enlargement. You may simply wish to make an ordinary size print of a small portion of a negative.

MAKING EXTREME ENLARGEMENTS

An extreme enlargement, for the purposes of this discussion, is one that requires magnifying the image beyond the normal capability of the enlarger. A factor that limits image size is the length of the column or girder supporting the lamp head of the enlarger. When you wish to make an enlargement greater than you can project on the baseboard of the enlarger with the head at its maximum height, you are entering the realm of extreme enlargement. Note that the desire to make a huge print is not the only reason for making an extreme enlargement. You may wish to make an ordinary-size print from a section of a negative. The following ways to make extreme enlargements may or may not be feasible for you, depending on the design of your enlarger. When in doubt, consult the owner's manual, manufacturer, or distributor.

Making a floor projection

Some enlargers are designed so that the head or column can be detached from the baseboard, swing 180 degrees to suspend the lamp head out past the rear edge of the baseboard, and reattached in the reversed position. If you can do this with your enlarger, place enough ballast on the baseboard first to prevent the weight of the head from tipping the machine when the column is reversed. In this configuration, the enlarger projects the image past the edge of the table or counter toward the floor. Regulate image size by raising or lowering the enlarger head and/or the easel.

If you have a continuing need for extreme enlargements, it may be more convenient to wall-mount the enlarger. Most enlargers allow removing the support column from the baseboard and remounting it on a solidly braced wall bracket. Buy or make an adjustable-height table that can support the easel anywhere from slightly above floor level to normal counter height.

Attaching the enlarger upright to a securely mounted wall bracket allows making extreme enlargements by lowering the easel as necessary, without interference from a baseboard.

When you reverse the column of an enlarger to make an extreme blowup, place enough weight on the baseboard to prevent the machine from tipping.

A home-built, variable-height enlarging table permits lowering the easel in steps almost to the floor level. Used in conjunction with a well-mounted enlarger, it permits great flexibility in controlling image size.

Focusing

When enlarging to high magnifications, the simple act of focusing the image becomes less simple than usual. When you are close enough to the easel to examine the projected image critically, you may be too far from the enlarger head to reach the focusing control. Extension focusing controls are sometimes available as optional accessories, or you may be able to improvise one.

An alternative solution is to press a cooperative friend, relative, or colleague into service to operate the focusing control while you inspect the image and tell him or her which way to turn the control and when to stop. In any case, don't expect image detail to look as sharp as it does at lesser magnifications. Focus on the grain. If the grain texture is well defined, the image is well focused.

WALL PROJECTION

A few enlargers permit swinging the lamp head to a horizontal position. This lets you project the image across the darkroom to an easel mounted on the opposite wall or on an intermediate vertical support.

Some enlarger systems include a front-surface mirror and mounting

Exposure and contrast

Exposure times become lengthy when you make extreme enlargements. To shorten times somewhat, use a high-speed enlarging paper such as KODAK POLYCONTRAST Rapid II RC, KODABROME II RC, or KODABROMIDE Paper. To prevent enlarger vibration, don't move about immediately before or during the exposure. Use a glass negative carrier, if possible, to hold the negative absolutely flat. Turn off the safelight during the exposure to avoid the possibility of fogging the paper during the long exposure.

If you are reprinting a picture you first enlarged to a smaller size, you will almost certainly have to use a more contrasty grade of paper or a high-contrast filter for the greatly enlarged version. And, no matter how carefully you calculate exposure and contrast requirements, make a test strip before exposing a large sheet of paper. Enlarging paper subjected to unusually long exposures may not respond in direct relation to exposure and contrast adjustments. If your enlarger can safely accept a more powerful lamp than the standard one, every bit of extra light helps.

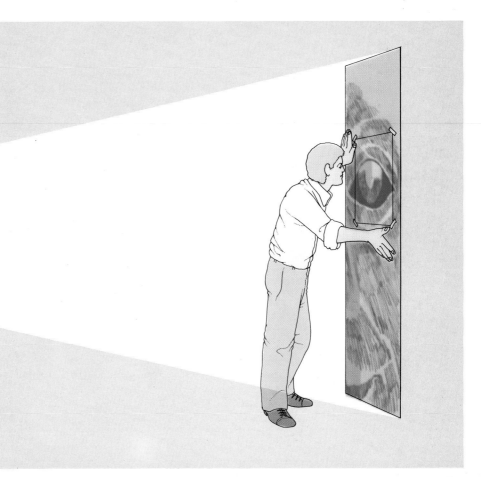

bracket among the optional accessories to permit making wall projections with models that don't have swinging heads. The bracket positions the mirror at a 45-degree angle beneath the lens, where it intercepts the image-forming light and flips it 90 degrees away from the lens axis.

Make focusing a two-person operation when the projected image is too distant for you to examine it critically and adjust focus simultaneously. Persuade a friend or associate to manipulate the focusing control in response to your instructions.

Special printing techniques

*Special printing techniques are like spices: a means of improving or adding zest to a basically sound recipe. If you have a good, interesting picture to start with, adding an appropriate embellishment may strengthen its visual appeal. No amount of darkroom manipulation, however, is likely to turn a dull, lackluster image into a winner. And as with spices, which are best added with a light touch, a little image manipulation goes a long way. The following special printing techniques are easy to master, are useful when applied with taste, and require minimal additions to your darkroom equipment and supplies. For information on advanced printing techniques, see the KODAK Workshop book, **Darkroom Expression.**

DODGING AND BURNING IN

Dodging and burning in are the opposite sides of the same coin. Dodging, or holding back, consists of selectively shading the enlarging paper with your hands or a dodging tool to reduce the exposure of certain parts of the image. Burning in, or printing in, consists of selectively exposing portions of the image longer than the overall print exposure. Dodging lightens the affected area. Burning in darkens the affected area.

You would employ dodging when a comparatively small area of an enlargement prints too dark relative to the rest of the image. Estimate by what percentage you wish to lighten the area, and multiply the overall print exposure by that percentage to determine how long to dodge. For example, if the print exposure is 20 seconds and you want to lighten an area by 50 percent, dodge it for about 10 seconds when you expose a new print.

Make a selection of dodging tools in odd shapes and sizes to help shade areas too small to dodge with your hands.

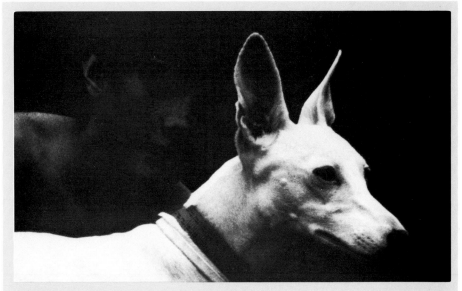

DODGING

You can use your hand to shade areas of various sizes and shapes. When dodging small areas, however, a dodging tool is easier to use. You can make a variety of dodging tools by taping or gluing bits of cardboard of different sizes and shapes to lengths of wire. Cover the dodging tool with black tape or flat black paint to prevent it from reflecting light onto the enlarging paper.

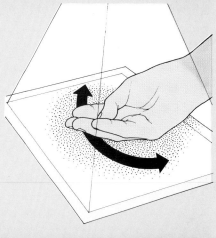

*In the straight, uncorrected enlargement, **above,** the shaded face prints much too dark when the rest of the image is correctly exposed. Dodging the shaded face during printing lightened it to a more acceptable density relative to the rest of the image.*

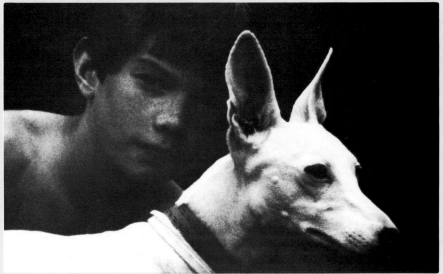

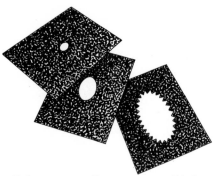

To burn in a small area, cut a small hole approximately the shape of the area to be darkened in a sheet of cardboard, and use the board to keep light from striking other parts of the image.

Burning in

Burning in is normally done to darken parts of the image that print too light relative to the overall picture. As with dodging, estimate the percent of change you wish in image density, but add it to the overall exposure. If the overall print exposure is 12 seconds and you want one area to look about 50 percent darker than in the straight print, burn in that area for an additional 6 seconds.

Again, your hands are the most versatile devices for controlling the light reaching areas to be burned in. For burning in a small area, though, such as a face in a crowd, you may find it more convenient to cut a small hole in a large sheet of cardboard and use it to keep light from spilling onto surrounding areas.

Fortunately, dodging and burning in are far easier to do than to explain. With experience, you will probably find yourself planning to dodge or burn in before you even make a test print, based on your inspection of the contact print.

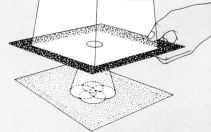

BURNING IN

When dodging or burning in, whether you use your hands or various implements, it is vital to keep moving to avoid creating a sharp and obvious boundary between the dodged or burned in area and its surroundings. Move your hands in a deliberately erratic, vibratory manner to keep the shadow moving enough to prevent forming a pronounced edge. You can also expand and contract the area you're working on by raising and lowering your hands within the beam of light projected by the enlarger.

In an uncorrected enlargement, the sky prints too light and looks washed out compared to the rest of the scene.

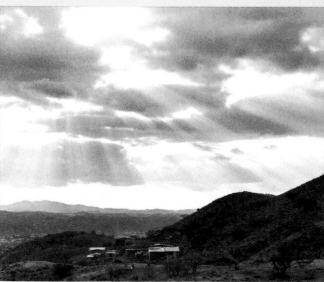

Burning in the sky about 50 percent longer than the basic print exposure darkened it enough to make a more attractive print.

*The straight print, **right**, had some areas that could be improved by dodging and burning in.*

*To make the final print, **below**, the darkroom technician first dodged (held back the light) in the shadow side of the child's face during a portion of the basic exposure. Next, he burned in (gave additional exposure) to the hair, left side of the woman's face, and background to create a more pleasing picture.*

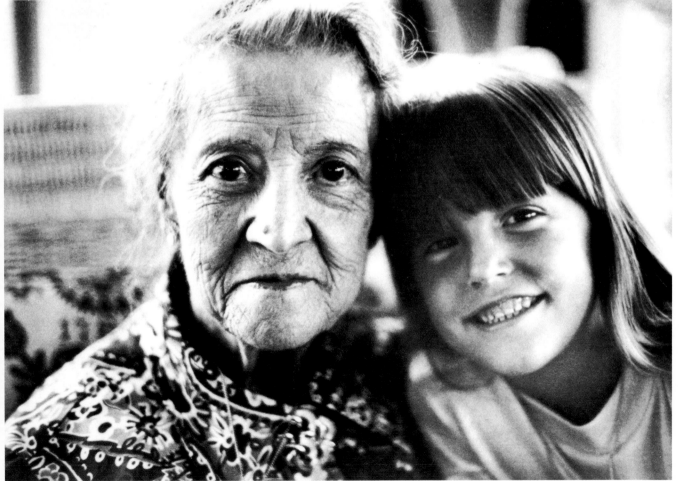

COMBINATION PRINTING

In combination printing, two or more negatives are used to make an enlargement. For an effective result, you should visualize in your mind how the combined images will appear in the finished print before getting started in the darkroom. Obviously, certain negatives will combine far better than others. A serious search for the right combination initially will save time and frustration later during the actual printing. The best candidates for combination printing include at least one negative with a large area of blank space. This space is where the image of the second negative goes during the printing.

If the blank space in the negative is a clear area and if both negatives are the same size, you may be able to sandwich them together in a glass negative carrier and print them both at once.

If the blank space in the negative is dense or if the images on the two negatives need to be enlarged to different magnifications, you'll have to make your exposures separately. Here's the procedure:

1. Put the negative with the blank space in the enlarger and compose the picture on the easel. Put a white sheet of paper in the easel and sketch the boundaries of the blank space. Remove the sketch. Make a test strip to determine the exposure of this negative, note the position of the enlarger and the exposure, and then remove the negative.

2. Put the second negative in the enlarger and place the sketch on the easel. Compose this negative in the area indicated on the sketch. Remove the sketch and make a test strip. Be sure to record the position of the enlarger and the exposure.

3. Print the second negative onto a fresh sheet of paper. Dodge any areas of the negative that might overlap and print into areas of the first negative. Mark the paper so that you can place it back in the easel in the same position, and put it in a lighttight box. Remove the negative.

4. Place the first negative back in the enlarger in the same position that you used for step 1. You can use the sketch to help you recompose the picture. Place the exposed paper back on the easel in its original position and print the first negative. If the blank area would turn out black, dodge it during this exposure. Process the paper in the normal way.

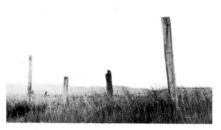

Two negatives—one of the fence with white sky and the other of clouds only—were printed separately on the same sheet of paper. While making the second (clouds) exposure, the lower part of the image was dodged so that the foreground would not receive double exposure.

Here the photographer used three separate negatives to produce the montage. First, while making the exposure of the stairwell negative, he did a considerable amount of selective dodging. Next he used a vignetter to print in the other two images into the areas that had been dodged.

The moon was added to this beach-scene combination print of two separate negatives. The beach negative was printed darker than normal for added drama.

VIGNETTING

Vignetting is a printing technique used to eliminate distracting or unwanted backgrounds. While this technique is most commonly used in printing enlargements of people, it can be extremely effective with a variety of other subjects.

You can easily vignette a print by projecting the image from the negative through a hole in an opaque cardboard. Cut the hole in the cardboard the same shape as the area you want to print. The hole should be the size that will give you the effect you want when you hold the cardboard about halfway between the enlarger lens and the paper. Feather or rough-cut the edges of the hole so that the image fades gradually into the white paper.

Commercially made vignetters are also available that are adjustable and have irregular edges to help produce the soft gradation between the image and the white paper. With any vignetter you're using, keep it in continuous motion during the print exposure to soften the edge of the image.

You can use the vignetting technique to print pictures from more than one negative on a single sheet of enlarging paper. Assume you want to print from three negatives. Decide where you want each image to appear on the final print, and draw circles on a sheet of white paper on the enlarger easel. These circles will indicate the location of each image. Put the first negative in the enlarger and adjust it so that the image you want fills its circle. Remove the white sheet of paper and make your exposure test for the first negative. It isn't necessary to use the vignetting technique for your exposure test.

Using the vignetting technique, make the first exposure on the enlarging paper that will be your final print. (It's a good idea to put a small "X" in one corner on the back of the

Vignetting eliminates the background, emphasizing the subject by isolating it.

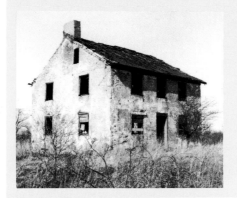

A vignetter is an opaque material with a hole in its center, which allows only a portion of the projected image to reach the enlarging paper. This commercially made vignetter can be adjusted to the size and shape you prefer.

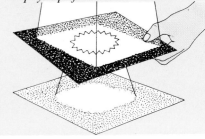

enlarging paper to help keep it properly oriented.) After you make the exposure, put the sheet of enlarging paper back into its lighttight storage place. Put the paper with the circles on it back into the easel and adjust the enlarger for the second picture. Follow the same procedure as you did for the first negative. After you've printed the second negative, follow this same procedure for the third negative. Then process the print.

To make the main subject in a print vignette to a black instead of white surrounding, first make a normal print. Then remove the negative from the negative carrier. Select or cut a

dodging tool in the shape you want the image to be. Attach the dodger to a length of wire and hold it above the easel, between the paper and enlarger lens. Turn on the enlarger lamp to fog the enlarging paper everywhere but where the dodger casts its shadow. Be sure to keep the dodger moving continuously to soften the transition from the image to the area of surrounding black tone. An exposure time equal to the time used to make the original negative exposure should be enough to provide a uniform, maximum black. Finally, process the print normally.

To create the black vignette **on the right,** the negative was removed from the enlarger. A dodging tool was held between the paper and the lens during the second exposure.

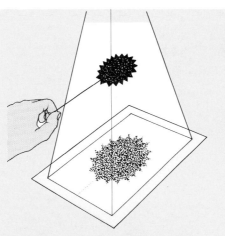

Keep the dodger moving continuously during the second exposure to avoid an abrupt change from the image to the surrounding print area, which will go black when developed.

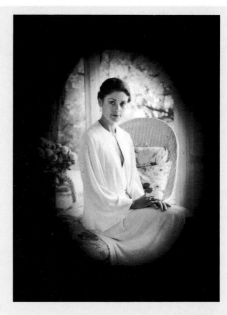

DIFFUSION

There are times when a sharp, precise image is not as desirable as a softer, less detailed rendition. This is often true when printing portraits or other subjects where you want to evoke a dreamy, romantic mood. To make a soft rendition from a sharp negative, you must diffuse the image while enlarging. Basically, this is accomplished by interfering with the image the enlarger projects. The diffusion effect in the print will vary according to whether you disrupt the image slightly or greatly. With any given diffusion device placed beneath the enlarger lens, the effect can be controlled to some extent by opening or closing the diaphram or the enlarging lens. Wider apertures produce softer images; smaller apertures yield less diffusion. At the smallest aperture, you may be aware of little or no softening.

Glass or plastic diffusion disks that can be mounted below the enlarger lens are available commercially. You can also improvise diffusers from almost any transparent, semitransparent, or translucent material at hand. For example, crumpled cellophane makes an ideal soft-focus attachment for use in diffusing an enlargement.

The simplest way to use any of these materials is to hold it under the enlarging lens during the exposure. Keep the diffuser in motion during exposure to prevent recording a pattern of its texture. If the material diffuses the image more than you like, hold it beneath the lens during only part of the exposure. The longer it disrupts the image, the greater the diffusion; the less time it is in the light path, the less the diffusion.

You may have to increase the exposure to compensate for any illumination that the diffuser might prevent from reaching the enlarging paper. Determine the correction by trial and error. You may also wish to increase the paper contrast slightly because the diffuser softens the image by spreading the light from the shadow areas in the negative into the highlights. The effect varies with the degree of diffusion.

Subtly applied, diffusion effects can be very attractive.

In portraiture, a tack-sharp print may prove unkind, even when the subject is young and attractive.

Diffusing the image during part of the printing exposure softened the rendition enough to make a much pleasanter picture.

*Printing through a commercial canvas-texture screen, **below,** produces an image, **left,** combining the pattern of the screen with the features of the subject.*

*The texture screen, **above,** was placed in contact with the photographic paper to produce the print, **below,** simulating the marks made by an etching tool.*

TEXTURE SCREENS

You can sometimes produce novel and interesting effects by printing a textured or patterned overlay in conjunction with a conventional negative. Special texture screens are available through photo dealers, and you can improvise your own easily and inexpensively.

There are three basic approaches to adding texture effects. One is to sandwich the texture material in contact with the negative emulsion in the enlarger, and project both images simultaneously. Another is to print the images successively on a single sheet of paper, replacing the negative with the texture material or vice versa for the second exposure. The third is to place a large sheet of texture material in contact with the paper emulsion, and print the image through it.

Printing the negative and texture pattern in a sandwich is easy, but you may have to use a glass carrier to hold them together flat enough to focus both sharply. Note that when you change image magnification, you also change the size of the projected pattern. A pattern that looks good at one magnification may be less attractive in a larger or smaller version.

Printing the negatives and textures separately with sequential exposures is more complex, but offers maximum flexibility in adjusting relative sizes of image and pattern. It also presents the possibility of making several exposures involving more than one negative and/or more than one pattern.

Placing a large texture screen in contact with the paper and printing through it is also an easy procedure. And it lets you change image size

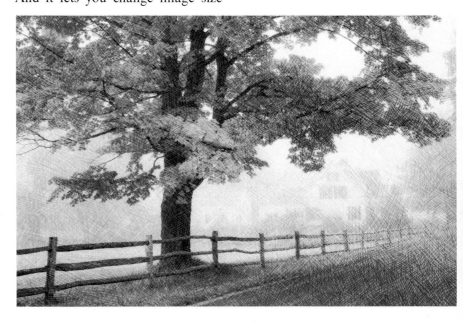

freely without affecting the size of the pattern. The drawback is that they cost more in larger sizes if you use commercially produced texture screens.

If you choose to make your own, try window screening, various fine and coarse nettings, facial tissues, tracing paper, rice paper, and textured glass or plastic, to mention just a few possibilities.

Depending on the material, you may use it directly or photograph it to produce a texture negative. Watch for interesting patterns and textures when you're out photographing, and collect the best on film for future use. If you wish, you can further en-large your texture negatives onto KODALITH Film or a similar high-contrast graphic-arts film, to make contact-size texture screens.

Printing with texture screens requires some patience and willingness to experiment to produce optimum results. The size relationship between the texture pattern and the image is crucial, so print several variations when everything is set up and readily at hand. The same applies to exposure and contrast variations too. Better to make a half-dozen versions and be pleased with one than to make just one and wonder later if it might not have been better with a few changes here and there.

This print was made by placing a section of window screening in close contact with the enlarging paper.

This print was made on a No. 4 grade paper. Reexposure during print development produced the Sabattier Effect.

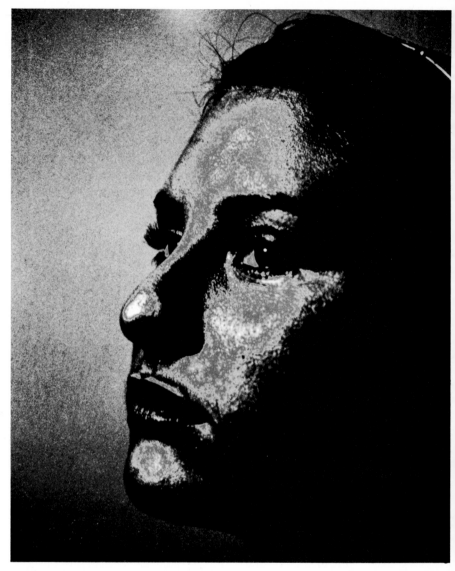

THE SABATTIER EFFECT

The Sabattier Effect produces both a negative and a positive image in a photograph and is characterized by a narrow line between adjacent highlight and shadow areas. The effect is produced by reexposing the film or paper to light while it's in the developer.

Many people incorrectly refer to the Sabattier Effect as solarization because the resulting images look similar. Solarization is the reversal of an image on the film (i.e., from a negative to a positive image) caused by extreme overexposure. The Sabattier Effect, as shown on these two pages, also produces a reversal image. But this effect is achieved by reexposing the film during development rather than extreme overexposure in the camera. The already developed image acts as a negative through which the rest of the light-sensitive silver in the film or paper is exposed. This produces some reversal of the image, and the result is part positive and part negative.

You can produce interesting pictures by the Sabattier Effect with most films and photographic papers, but there is an advantage to working with film. After producing a negative with the Sabattier Effect, you can make as many prints as you want from that negative. If you try the technique on paper, you may not be able to produce another print exactly the same.

Whether you're working with film or paper, these variables will affect the amount of reversal:
1. the amount of reexposure
2. the extent of development after reexposure, and
3. the time during development when the reexposure takes place.

If the reversal effect is too strong for your liking, reduce the reexposure or develop the material longer before reexposing. If you want to obtain more reversal of tones, increase the

reexposure or make the reexposure earlier in the development. Generally, you'll get the best results when reexposing the film or paper at about one third the development time. Stop agitating about 10 seconds prior to reexposure and allow the film or paper to settle to the bottom of the developer tray. After reexposing, continue the development to the normal development time for the first exposure and use continuous agitation. Always use fresh developer and stop bath solutions, diluted for normal use.

Some subjects will produce interesting pictures when the Sabattier Effect is tried directly on photographic paper. However, many prints will simply look as though they've been accidentally fogged. If you are not pleased with your results, try printing your negative or slide onto a

sheet of normal- or high-contrast film. KODAK Commercial Film 6127 works well if you want continuous-tone results. KODALITH Ortho Film 2556, Type 3, will produce dramatic, high-contrast results.

Printing onto a sheet of film in the darkroom and trying the Sabattier Effect during development is the safest way to experiment with the technique. If you try reversing the original image, you risk ruining it. But if you save your original image and use it to print onto other films, you can experiment all you want without damaging the original film.

Negatives made with the Sabattier Effect have a high fog level and are difficult to judge visually. To see the effect best, make a print. These negatives will usually print better on a higher-than-normal-contrast paper.

Reexposure, partway through development, gave this print a silver, fantasy-like quality. To reexpose the print, the tray of developer, containing the print emulsion side up, was placed under the enlarger light source. A 6-second exposure was made with the enlarger light (no negative in the carrier).

THE SABATTIER EFFECT WITH PHOTOGRAPHIC PAPER

1. Make a test strip to determine the exposure for a normal print. Process the strip in a normal working solution of paper developer for 90 seconds.

2. Expose a fresh sheet of paper, using the exposure you determined from the test strip.

3. Develop the paper, emulsion up, for 20 seconds with continuous agitation. Let the paper and developer settle for 10 seconds (no agitation).

4. Reexpose the paper to white light while it's in the developer. (A good light source is a safelight without a filter. Try an exposure time of 2 seconds at a distance of 4 feet *1.2 m* as a starting point.)

5. Resume and continue agitating until the total time of 90 seconds has elapsed.

6. Rinse the paper in stop bath. Then fix, wash, and dry the paper normally.

With high-contrast films, the Sabattier Effect produces dramatic outlines, accenting elements within the image.

THE SABATTIER EFFECT WITH FILMS

1. Make a test strip to determine the exposure and process the film in its recommended developer. After fixing, select the best exposure time from the strip.

2. Print your original image onto a fresh sheet of film using the time you determined from the test strip.

3. Place the film in the developer, emulsion (sticky) side up, and develop with continuous agitation for 25 percent of the total development time. Let the film and developer settle for 10 seconds (no agitation).

4. Reexpose the film to white light while it's in the developer. (A safelight without a filter works fine.)

5. If you're using a continuous-tone film, resume agitation and continue until the total development time has elapsed. If you're using a high-contrast film, you'll get a more pronounced narrow line between highlight and shadow areas by allowing development to continue *without agitation* for the total development time.

6. Rinse the film in stop bath, and fix, wash, and dry it normally.

55

PHOTOGRAMS

A photogram is a tonally reversed print or enlargement made directly from the subject, rather than from a negative of the subject. Depending on the subject size and shape, you may be able to place it directly on the enlarging paper, or if it is small and flat enough, you can put it in a glass negative carrier and enlarge it as you would a negative. Opaque materials

Several short exposures were made to create this photogram. After each exposure, the prop (a carpenter's square) was moved to a new position on the photographic paper.

Photograms made from translucent subjects, such as these delicate leaves, display tonal modulations that reflect the varying densities of the subject.

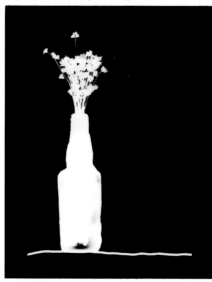

produce high-contrast black-and-white records of the shadows they cast on the enlarging paper. Translucent and transparent subjects yield photograms with varying tones that can be manipulated with regard to contrast and overall print density, as in conventional enlarging. Additional control is possible through dodging and burning in.

Your enlarger serves as the light source for both types of photograms. When placing the subject directly onto the enlarging paper, make a trial setup first, using the back of an old

print to determine the best placement of the object or objects. Adjust the enlarger height and focus as necessary to cast the sharpest outlines, and stop the lens down to a small aperture. For high-contrast renditions of opaque objects, exposure time isn't critical. It should be long enough to provide a good solid black, but not so long as to degrade the highlights. With subjects that yield middle tones, determine best exposure by making test strips. Exposure times can be held within reasonable limits by using a high-speed enlarging paper.

An opaque bottle, bunch of dried flowers, and a piece of wire were combined to make this photogram still life.

This photogram was made directly from the props rather than from a photographic negative or positive. The props were placed on the photographic paper beneath the enlarger, which served as the light source. The enlarger lens was set to a small aperture to cast the sharpest possible outlines.

CONTRAST MANIPULATION

Changes in print contrast are generally intended to produce a normal-looking picture with a conventional tonal range. But some subjects lend themselves to deliberate high-contrast printing that can produce very strong, poster-like results. Typically, the technique is most successful with sharp, cleanly delineated subjects that are rich in contrast to begin with. The best candidates for high-contrast printing have prominent highlights and shadow areas, with few middle tones of significance.

Instead of printing on a normal-contrast paper, print on the highest contrast grade. With Kodak papers, contrasts designated as 5 or Ultra Hard, are most suitable. For Kodak selective-contrast papers, use a KODAK POLYCONTRAST II Filter PC5. To boost print contrast further, dodge areas you wish to lighten and burn in areas you wish to darken.

For best results in high-contrast printing, use freshly prepared developer and agitate the print vigorously during development if you are processing in trays. Clean the negative well, because high-contrast printing makes dust particles on shadow areas show up brilliantly white on the paper. Generally, the technique is straightforward and easy to apply. Obtaining attractive results depends less on darkroom skill than on picking appropriate pictures to receive the treatment.

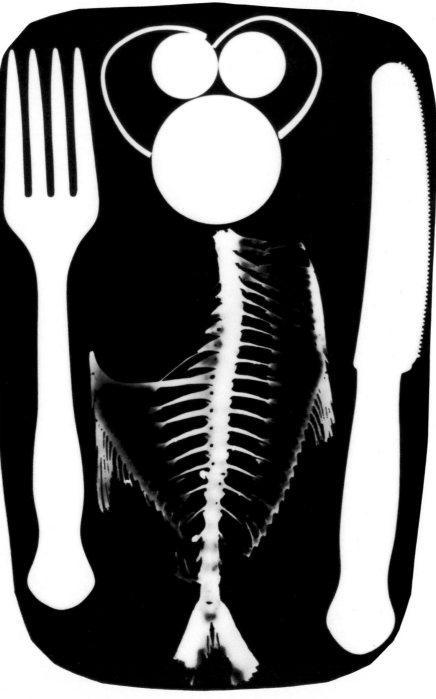

Print processing

Processing black-and-white prints is a simple procedure that rewards care and consistency. No special skills are needed, you can see what you're doing under safelight illumination, and if you do make a mistake, it needn't bother you longer than it takes to expose another print and process it correctly.

READ DATA SHEETS AND INSTRUCTIONS
Consult the data sheet packed with your enlarging paper to see what processing chemicals the manufacturer recommends, how long the paper should be treated in each solution, and what special techniques, if any, are required. As with film developing, familiarize yourself with the entire process before beginning.

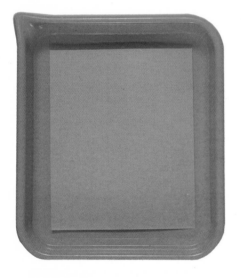
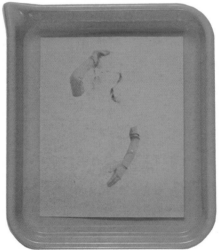
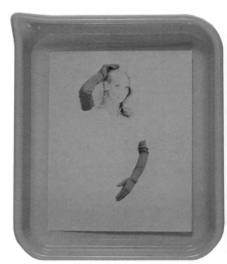

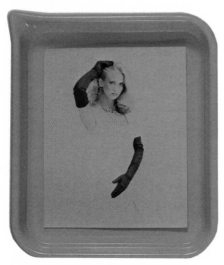

58

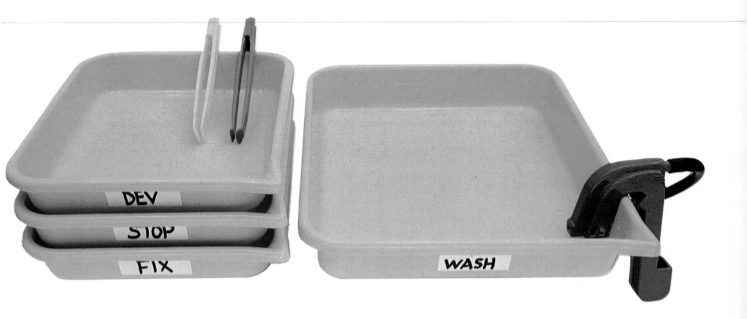

Processing trays are available in models made of plastic, enameled metal and stainless steel. Plastic trays, such as the KODAK DURAFLEX Trays, are light and easy to handle. Metal trays are heavier but more rigid. Enameled trays must be handled carefully to avoid chipping the enamel. A simple, economical, and effective means of washing small to moderate quantities of prints consists of a KODAK Automatic Tray Siphon clipped to the edge of a large processing tray.

There are two basic procedures for processing black-and-white prints in small darkrooms: with trays in a sink or on a countertop; or with a compact, tabletop machine called a stabilization processor. The two methods differ greatly, so they will be discussed separately.

TRAY PROCESSING

Processing prints in trays requires the least initial outlay for equipment and accommodates the widest variety of photographic papers.

THINGS YOU'LL NEED
TO PROCESS PRINTS IN TRAYS

1. Four or more processing trays
2. Two pairs of print tongs (optional)
3. Developer
4. Stop bath
5. Fixer
6. Storage bottles for developer and fixer
7. Print washer (optional)
8. Hypo clearing agent (optional)
9. Paper cutter
10. Print dryer (optional)
11. Additional darkroom timer (optional)
12. Scissors, graduates, stirring paddle, darkroom thermometer, plastic mixing tub, darkroom timer, and funnel you already use for processing black-and-white film

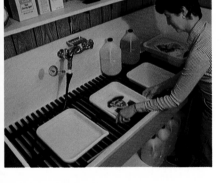

Processing prints manually in trays requires the least outlay for equipment and works with a wide variety of materials.

Stabilization processors such as the KODAK EKTAMATIC Processor, Model 214-K, take up little darkroom space and can produce a damp-dry, finished 8 x 10-inch (20.3 x 25.4 cm) print in about 15 seconds. However, they can only be used with special stabilization papers.

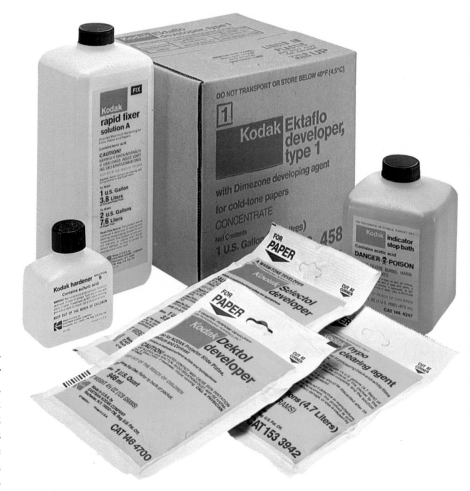

Choosing a developer

For best results, select a print developer recommended by the paper manufacturer. If several are listed, pick one that is readily available in convenient-size packages. The cost per unit of photographic chemicals sometimes drops sharply as package size increases. Buy the largest sizes you can realistically expect to use up without risking spoilage on the shelf.

Many paper developers, such as KODAK DEKTOL Developer, are supplied as a powder that must first be mixed with water to form a stock solution, which in turn is further diluted to make a working solution. Stock solutions normally withstand storage well. Working solutions must be used promptly and discarded after use.

Other paper developers, such as KODAK EKTAFLO Developers, are packaged as liquid concentrates, ready for immediate dilution to working strength. Concentrates keep well and require little storage space compared to stock solutions.

KODAK Paper Developers

DEKTOL	For neutral and cold-tone images on cold-tone papers, such as KODABROMIDE, KODAK POLYCONTRAST, and PANALURE. High capacity, uniform development rate, good keeping.
EKTAFLO, Type 1	A liquid concentrate which dilutes 1 part concentrate to 9 parts water with characteristics similar to those of DEKTOL Developer.
SELECTOL	For warm-tone papers, such as KODAK EKTALURE, and warmer tones on other papers.
SELECTOL-SOFT	A companion to SELECTOL Developer, gives lower contrast.
EKTONOL	Noncarbonate developer for warm-tone papers, such as KODAK EKTALURE and Mural. Minimizes stain on prints which are to be toned.
EKTAFLO, Type 2	A liquid concentrate with characteristics similar to those of EKTONOL Developer which dilutes 1 part concentrate to 9 parts water.

Some print developers, such as KODAK DEKTOL Developer, come in powder form. They must be mixed with water to make a stock solution that is further diluted for use as a working solution. Other developers, such as KODAK EKTAFLO Developers, are supplied as a liquid concentrate that is diluted directly to a working-strength solution immediately before use.

Mixing and storing chemicals

The same principles apply both to mixing and storing printing chemicals and to processing film. If you use the same brand and type of stop bath and fixer for film and paper, however, double-check the mixing instructions. Dilutions recommended for use with film and paper are often different. Even when the dilutions are the same, prepare separate batches for processing film and paper. Print fixer might accumulate small particles of paper or emulsion residue with use. Such particles are best kept away from film emulsion.

Keep a log of how many prints of each size have passed through a given quantity of solution. Discard the solution when you approach its rated capacity. And discard any solution, regardless of usage, when it has been stored longer than the published shelf life. Pour fixer into a large bottle after each printing session. It will last much longer than if it stands in an open tray.

Temperature control

Black-and-white photographic paper, like film, is developed by time and temperature. Try to begin every printing session with the developer about 68°F *20°C*, or whatever temperature is recommended. Other solutions and rinses should be between 65°F and 75°F *18°C and 24°C*.

If the storage temperature of solutions is not correct, place the storage bottles in a water bath (large tub of hot or cold water) until the contents are sufficiently warmed or chilled. If developer stock solution or concentrate must be diluted to a working solution, mix with water warm or cool enough to make a working solution close to the desired temperature.

Unless the ambient temperature in your darkroom approximates the desired working temperature, solutions will gradually drift away from the starting temperature as you print. Don't worry about it. Print density and contrast will be affected gradually enough for you to compensate as you go, without conscious thought. As long as you begin every printing session with the developer at the same temperature, you will have a uniform point of departure for zeroing in on exposure and contrast. Test strips and trial prints will tell you what you need to know.

Large stick-on labels on developer and fixer storage bottles are good places to keep records of dates mixed and print quantities processed.

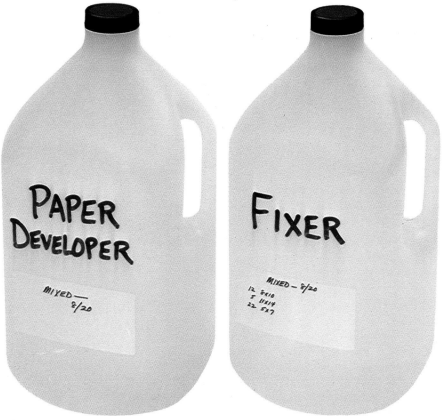

Setting up the trays

Standard darkroom practice calls for lining up the processing trays in the sink or on a counter in the order of use: developer, stop bath, fixer, and a holding tray filled with water. To avoid the chance of possible chemical contamination in future processing sessions, label the developer tray and use it for no other solution.

Darkroom layout permitting, the developer tray should be nearest to the enlarger. If you are planning a darkroom, keep in mind that right-handed workers find it convenient to move down the line of trays from left to right, while left-handed people often prefer to run the sequence from right to left.

If you are working on a counter top or table, spread a plastic sheet to protect the surface. Then put a layer of newspapers beneath the trays to absorb minor spills, of which there will inevitably be many. When space allows, set the developer tray apart from the others to reduce the likelihood of contaminating the developer with splashes of stop bath or fixer, both of which contaminate developer.

Trays should be large enough to accept a sheet of enlarging paper with at least an inch *2.54 cm* of clearance on each side. Fill trays with solution to a depth of one-half to three-quarters inch *1.25 to 1.9 cm*, depending on the height of the walls. Too shallow a pool makes it difficult to keep the print submerged. Too deep a pond causes spills when trays are rocked to agitate solutions.

Again, if you are planning a darkroom, specify a processing sink or counter height that places trays high enough to reach without stooping, but low enough for easy access without awkward arm raising. Convenient tray height makes a tremendous difference in darkroom comfort when you work for several hours at a stretch.

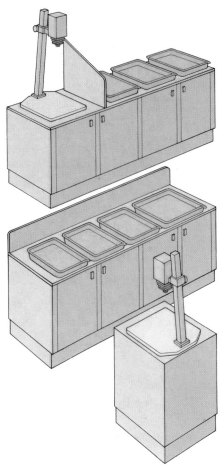

Processing trays should be large enough to provide at least 1 inch 2.54 cm of clearance around the print for easy handling.

*The darkroom counter units shown **at left** consist of a dry bench and a wet unit, each 26 inches 66 cm wide. You can either have them built in a woodworking shop or assemble them yourself from ready-made kitchen cabinets. Arrange your work area so that you can function efficiently with a minimum of wasted motion. To save steps, place the developer tray nearest the enlarger.*

Print Tongs

Wear gloves when working with chemicals. In addition, prints should be transferred from tray to tray with print tongs. Even if you are not susceptible to skin allergies, sensitivity to chemicals can develop after years of trouble-free work. Using tongs minimizes skin contact with processing solutions and reduces the likelihood of staining prints with chemical-laden fingers.

Label one pair of tongs **developer,** and use it only to handle prints wet with developer. Never let the developer tongs contact stop bath or fixer.

Label the second pair of tongs **acid,** and use them for all other print-handling chores. Never let these tongs touch or drip into print developer.

Print tongs should be used to handle prints during processing. Use separate tongs for developer and stop bath and fixer. Mark them prominently to avoid mix-ups.

DEVELOPING PRINTS

When you remove the exposed print from the easel or contact frame, hold it by the edges to avoid finger marks on the emulsion. Develop the print for the time recommended by the developer or paper manufacturer. Most black-and-white enlarging papers develop fully in 1 to 3 minutes. With many papers, 2-minute development is long enough to provide rich, intense blacks, but not so long as to degrade highlights. Whatever development period you decide to use, be consistent and use it all the time.

You can time print processing with the enlarging timer, but doing so is slightly inconvenient because of the need to switch off the enlarger or disconnect it from the timer and to reset the timer. It's easier to use a clock with a second hand or a timer that indicates seconds. Place it at a convenient height above the processing area—on a shelf or fastened to the wall.

Start the timer or note the position of the second hand and slide the print into the developer tray, emulsion up. To submerge the print evenly, angle the leading edge downward into the developer. Immediately pick up the

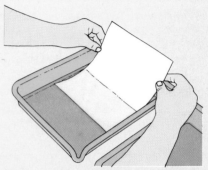

developer print tongs and gently push down the corners and edges of the print if they start to rise above the surface of the solution. Many papers curl noticeably when first immersed, then relax again. Without delay, begin rocking the tray to agitate the developer.

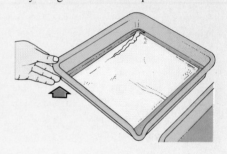

the solution with the tongs. You will probably have to do this often enough to warrant keeping the tongs in hand while rocking the tray.

Cleaning your equipment

Tray processing is inherently sloppy. There is no way to agitate solution in an open tray without spilling some every now and then. Use the downtime while your prints are washing or drying to wash the processing trays and other equipment. Use hot water, and flush the exterior of the trays as well as the interior. Wash the sink or counter where you process prints. Chemical residues are easy to remove when still fresh, but can set like concrete if left too long. It isn't difficult to keep a darkroom clean, but cleaning a darkroom that has been allowed to become dirty is a nasty chore.

Agitation

Agitate the developer tray continuously through development to keep fresh solution moving across the print emulsion. Gently lift a corner of the tray and then lower it. Repeat this action frequently to keep the developer in constant, random motion.

Stop agitating about 10 seconds before the total developing time is completed. The specific agitation rate doesn't matter greatly, but be consistent. Do it the same way every time.

If the print surfaces during agitation, gently push it back down into

Ten seconds or so before development is up, stop agitation and lift the print from the developer tray with the tongs. Pinch just the corner of a small print or the midpoint of a short edge of a larger print between the tongs. Lift the print gently to avoid folding or tearing it.

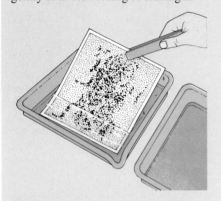

Suspend it above the developer tray to drain. When your timer indicates the end of development, transfer the print to the tray containing stop bath. Lower the print edge first into the tray, but do not dip the developer tongs into the solution. Release the print when the tongs are still a short distance from the

surface of the liquid. Place the tongs near or astride one edge of the developer tray. Begin agitating the print in the stop bath immediately and vigorously for about 5 to 10 seconds. You can time the stop bath stage or estimate it by counting slowly. If you run over a bit, no harm will be done.

This step stops developer action and removes excess developer from the print before it enters the fixer. An acid stop bath, such as KODAK Indicator Stop Bath, almost instantly neutralizes any developer remaining on and

absorbed by the print.

If you do not have stop bath available, you can use a water rinse instead. Plain water weakens residual developer and slows down development. If you replace fixer often and rarely work it to capacity, an intermediate water rinse is sufficient. If you intend to save your fixer and work it to capacity, use an acid stop bath to avoid premature weakening.

When the print has been in the stop bath for the required time, lift it to drain briefly with the second pair of

Develop for the full time

Shortly after the print enters the developer, you will see the image materialize, slowly at first, then at an accelerating rate. If the print was significantly overexposed, the image will come up very fast and darken excessively as you watch. Resist the urge to yank the print from the developer in an attempt to save it. A print pulled from the developer before development is complete may look muddy and perhaps mottled.

If the print was underexposed, it will still look weak and unfinished when the developing time expires. Don't extend development in an effort to develop what exposure failed to put on the paper. Overdeveloped prints will not become noticeably darker. You will only be wasting your time.

tongs, then lower it edge-first into the tray of fixer, noting the time.

Agitate the print briskly in the fixer.

After the print has been fixed for at least 30 seconds, you can turn on the room lights. Before doing so, though, check that envelopes or boxes of enlarging paper are properly closed.

If several prints are in the fixing tray, agitate often enough to keep them separated so that fixer can reach all parts of each sheet. Follow fixing time recommendations carefully. Overlong fixing may bleach the print, change the image tone, and make it difficult to wash adequately. Keep track of how

many prints of what size you have run through the fixing bath, and discard it when you approach the rated capacity.

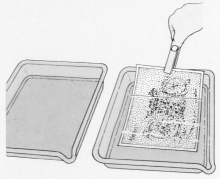

Finally, lift the completely fixed print from the tray and begin the washing procedure.

Two-bath fixing

If you process large numbers of prints fairly frequently, you may wish to use a two-bath fixing procedure. Prepare two separate quantities of fixer and store them in containers labeled *Fixer No. 1* and *Fixer No. 2.* In the darkroom, lay out two fixer trays, filling the first from container No. 1 and the second from container No. 2. Fix a print initially for one-half the recommended time in the first tray and for the remainder of the fixing time in the second tray, following a normal agitation cycle. When fifty 8- x 10-inch prints or the equivalent have been fixed per quart *946 mL* of first-bath fixer, dump the first fixing bath and use bath No. 2 as the new first bath. Use freshly prepared fixer as the new bath No. 2. Repeat the cycle until a total of 250 8- x 10-inch prints or the equivalent have been fixed. Then discard both baths and start fresh.

This method virtually makes sure of good fixing because the fixer in the first tray absorbs the chemical impact of residual developer carried over in the print fibers and emulsion, while bath No. 2 completes fixing in a comparatively fresh, uncontaminated solution that, in a sense, cleans the print while fixing it. As a result, the print will wash cleaner faster than if it had been fixed by the single-bath method.

When fixing time is up, drain the print a few seconds over the fixer tray and transfer it either to a holding tray of water or to the washing vessel. Replace the tongs near the stop bath tray or astride one edge of it.

*A print removed from the developer too soon, **far left,** will usually appear weak or muddy due to underdevelopment. When developed for the full time, **left,** it will exhibit a full range of tones with a rich black, providing exposure was correct.*

*Incomplete fixing or using exhausted fixer can produce stain in a print, **above**, that will continue to darken with age.*

*Poorly washed black-and-white prints will become stained in time, as has this sad example, **left**.*

WASHING PRINTS

Prints must be washed to remove fixer and chemical salts that have been absorbed by the emulsion, and with conventional fiber-based papers, by the paper backing. Prints that are not adequately washed will eventually stain and fade.

You can accumulate prints made on fiber-based papers in a holding tray or washing vessel filled with fresh water until all the prints produced during your printing session are ready to wash. If you will be printing for several hours, change the holding bath every 30 minutes or oftener to prevent it from building up a high concentration of fixer. Each time you add a print, move the prints in the bath and separate them so that they don't mat together in a stagnant mass of fixer-laden paper. The temperature of water in the holding vessel should approximate that of the processing solutions.

When the last print is in the holding tray, you can begin washing. It is pointless to start washing a batch of prints if you will be adding unwashed prints later on. The fixer carried in on the unwashed prints will recontaminate partially washed prints. Washing time is counted from the entry of the last fixed print into the washing container.

Washing devices can be as simple or as elaborate as your funds and/or requirements dictate. Whether you are simply running water into a tray containing prints or using a complex washer that swirls a load of prints in a whirlpool, the object is to circulate clean water rapidly past all the print surfaces. Watch the wash process and periodically separate prints that clump together. The wash water can-not clean print areas it cannot reach. Adjust the water flow to keep prints moving and separated, but don't blast it in the washing vessel so forcefully that it damages the prints. The flow rate should be fast enough for at least 10 to 12 complete changes of water per hour.

Hold water temperature between 65°F and 75°F *18°C and 24°C*. Colder water will not remove fixer efficiently. Warmer water may make the print emulsion swell excessively and render it vulnerable to damage.

Most fiber-based papers should be washed for an hour. Consult the manufacturer's data sheet for specific recommendations applicable to the materials you use.

Washing resin-coated papers

Resin-coated black-and-white papers such as KODAK POLYCONTRAST Rapid II RC and KODABROME II RC Papers require much shorter wash times than fiber-based papers because they absorb much less fixer. They should not, however, be held after fixing for mass washing later. Resin-coated papers should be washed immediately after fixing. Kodak resin-coated papers wash

A simple, economical, and effective means of washing small to moderate quantities of prints consists of a KODAK Automatic Tray Siphon clipped to the edge of a large processing tray.

fully in 4 minutes. Do not exceed this time. Prolonged wet time may allow moisture to penetrate the water-resistant print coating near the edges.

Because of the short washing time required by resin-coated paper, it is both practical and desirable to process a single print to completion before making the next one.

Washing without running water

If you do not have access to running water for print washing, use a series of twelve 5-minute water soaks. Set aside enough clean water to fill the wash tray or tub 12 times. Interleaf the prints constantly in clean water for 5 minutes, then empty the tray and refill it with fresh water and repeat the procedure. After 12 cycles, the prints should be well washed. With resin-coated papers, four 1-minute treatments will do.

Chemical washing aids

To reduce wash time and water consumption when washing fiber-based papers, you can use a washing aid such as KODAK Hypo Clearing Agent. First rinse the prints in rapidly running water for 30 seconds to a minute. Then agitate the prints in a tray of hypo clearing agent, interleafing the prints to be sure of even exposure to the solution.

Treat single-weight prints for 2 minutes, double-weight prints for 3 minutes. Follow with a water wash of 10 minutes for single-weight or 20 minutes for double-weight papers. Longer washing times may be used. Another advantage of hypo clearing agent is that it permits thorough washing in very cold water. For information on maximum image stability, see the Kodak publication F-40, *Conservation of Photographs*.

DRYING PRINTS

Print drying paraphernalia range from a few wooden clothes pins on a line to rotary drum dryers heated by gas or electricity and capable of drying a hundred or more prints per hour. Conventional fiber-based photographic papers can be dried by the full gamut of improvised and commercially available dryers. Resin-coated papers, for the most part, should not be dried by any method involving exposure to high heat.

Hanging prints to dry works well with all papers if you're not in a hurry. Wipe each print gently front and back with a soft sponge or clean,

You can air-dry prints just by hanging them up if you're not in a hurry.

lint-free towel to remove excess surface moisture, and hang it by an edge or corner from an overhead line in a dust-free area. Use wooden clamp-type clothes pins to hang the prints. In very dry weather, treat fiber-based prints in a flattening solution first to reduce curling. Resin-coated papers air-dry quickly and remain quite flat.

For a quick, inexpensive method of drying prints, first remove excess water with a squeegee or soft sponge. Then apply warm air evenly with a portable hair dryer.

SCREEN DRYERS

If space permits, you can use drying racks to air-dry prints. The simplest of such devices consists of a slotted support structure into which you slide horizontal racks made of plastic window screening stapled to light wooden frames. Air circulating between the racks eventually dries the prints that are resting emulsion up on the screens. Prints curl less when dried on racks than when suspended.

RC Dryers

Small tabletop, hot-air dryers are available for drying resin-coated papers quickly. They also work with fiber-based papers, but more slowly because of the greater amount of retained moisture. Avoid high heat settings, which can damage resin-coated papers and cause excessive curling and brittleness with fiber-based material.

If you do not have a regular print dryer, you can greatly reduce the drying time by blowing hot air onto prints with a portable home hair dryer. Keep the dryer moving so that the hot air is not concentrated in one spot too long. The temperature of the air should be below 200°F *92°C.*

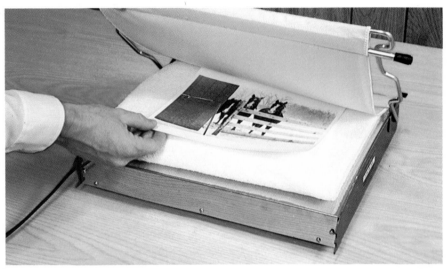

Small, tabletop dryers dry resin-coated papers very quickly. They can also dry fiber-based papers, but more slowly because of their greater water retention.

Flat-bed and rotary dryers

Heated flat-bed or rotary dryers can be used to dry fiber-based papers quickly. Conventional designs employ a heavy cloth belt or apron to hold the print against a heated polished metal plate or drum. When using a glossy finish paper, you can make high-gloss prints by placing them in the dryer so that the emulsion is pressed firmly against the polished metal heated surface. If you are preparing glossy prints, bathe them first in a flattening/glossing solution and drain them briefly before placing them in the dryer.

Glossy and non-glossy papers can be dried to a non-glossy finish in the same machine by placing the prints with the emulsion facing the cloth belt or apron, and the paper backing toward the metal heating surface. Wipe excess moisture from both sides of the prints before putting them into the dryer. Treatment with flattening/glossing solution is unnecessary for non-gloss drying.

If you use a heated dryer, it is imperative that you operate it as directed by the manufacturer. For safety sake, make sure the electric circuit powering the dryer is adequate for the current load and is properly fused. Most dryers should be turned on several minutes early to reach proper operating temperature. You may have to experiment to find the best temperature setting for the paper you use. With a rotary drum model, you will also have to experiment to find the best operating speed/temperature combination for your materials. Generally, lower temperatures and slower speeds work best, minimizing the amount of print curling. You may have to adjust settings to compensate for unusually humid or dry weather.

Always dry your hands before changing settings of electrical dryers. And don't leave a dryer unattended while it is running. When you are

through drying prints, shut the dryer down in the exact sequence recommended by the manufacturer. Also, never put an inadequately washed print into a dryer, because fixer residues will soak into the belt or apron, transferring the contaminants to prints that are later placed in the dryer.

Flattening prints

Fiber-based prints may develop a pronounced curl upon drying. This is most likely to occur when prints are glossed at high heats in a drum dryer during a period of low relative humidity. The curl tends to relax in time as the print absorbs moisture from the surrounding air. If you have access to a dry mounting press, you can reduce the print curl by clamping each print in the heated press for several seconds. Place the print into the press with the convex surface toward the heating platen. A rotary drum dryer can be used to reduce print curl by running the dried prints through it at a low temperature and drum speed with the print curvature opposite that of the drum.

When you're not in a hurry, simply lay the prints out in a moderately humid environment for a few hours. If nature is uncooperative, you can create the humid environment by

running a hot shower for a few minutes or boiling a pot of water. It's not a good idea to attempt to reduce print curvature by flexing the print against the curl. It sometimes works, but you risk cracking the emulsion.

Print flattening agents

Print flattening and glossing agents, such as KODAK Print Flattening Solution, are sometimes used after washing fiber-based papers that are to be dried on a heated dryer or dried to a high-gloss finish with or without heat. These compounds are hygroscopic, inducing the dried print to retain enough moisture to reduce its tendency to curl in a dry environment. The print thus remains more flexible and is less prone to damage when handled. These solutions also promote clean release of the print emulsion from polished metal drying surfaces used in high-gloss drying. Print flattening and glossing agents should not be used with resin-coated papers.

Prints are normally bathed in the solutions for approximately 5 minutes, then drained briefly, and dried. Consult the instructions accompanying the product you choose for appropriate dilutions and times for the materials you use and the circumstances in which you use them.

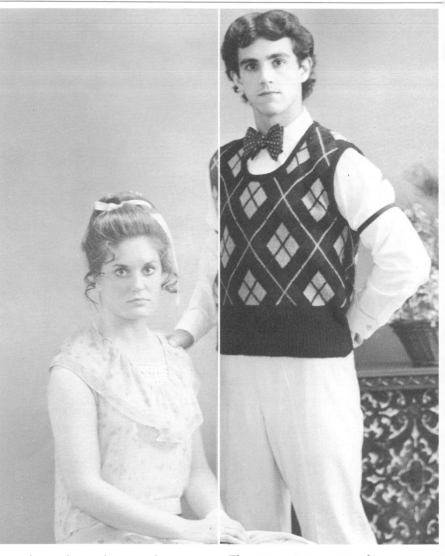

TONING

Print toners are chemical solutions that alter the color of the developed image. Most toners produce color changes tending toward warmer, brown-black or sepia images. The degree of color change a toner produces depends both on the basic image tone of the enlarging paper and the length of time the paper is immersed in toning solution.

The decision to tone or not to tone pictures represents an aesthetic choice. Some pictures may be improved through judicious warming of the image tone. Others may not. As a rough guideline, to which there are valid exceptions, portraits and other photographs in which people are prominent may benefit from warm toning.

If you would like to experiment with toning pictures, first determine what commercially available toners are compatible with the enlarging paper you use. Not all toners work well with all papers. *See table.*

These two prints were toned, respectively, in Sepia Toner and Rapid Selenium Toner.

KODAK Paper	Developer	POLY-TONER 1:4	POLY-TONER 1:24	POLY-TONER 1:50	Brown	Sepia	Rapid Selenium 1:3	Rapid Selenium 1:9
EKTALURE	SELECTOL	3	3	3	3	3	3	3
EKTAMATIC SC	DEKTOL	0	1	1	2	3	0	0
ELITE Fine-Art	DEKTOL	2	2	2	3	3	1	1
KODABROMIDE	DEKTOL	0	1	1	1	3	0	0
KODABROME II RC	DEKTOL	1	2	2	3	3	0	0
Mural	SELECTOL	2	2	3	3	3	2	2
PANALURE	DEKTOL	0	1	1	3	3	0	0
PANALURE II RC/Repro RC	DEKTOL	0	2	2	2	3	1	1
POLYCONTRAST Rapid II RC	DEKTOL	0	1	1	3	3	1	1
POLYFIBER™	DEKTOL	1	2	2	3	3	2	2
POLYPRINT RC	DEKTOL	1	2	2	2	3	1	0

0 No tone change
1 Slight tone change
2 Moderate tone change
3 Full tone change

Untoned print.

Make sure that the prints you intend to tone are washed thoroughly to remove all traces of fixer and chemical compounds formed during processing, which can cause uneven toning or noticeable straining. And perform the toning in a plastic or other nonmetallic tray. Most toners react adversely to contact with metal.

Follow instructions for preparation and use of toners to the letter. Some toners alter print density and contrast sufficiently to require specially made prints for optimum quality. The print that looks best to you untoned may become noticeably darker or lighter, or assume different contrast characteristics after toning. Changes in tone occur gradually over a period of several minutes. Watch carefully and remove the print from the toner as soon as it looks right to you. It helps to keep a wet untoned print nearby for comparison. If you decide later that the print could use more toning, you can always repeat the process. There is no practical corrective action you can apply to a print that has been toned too long.

Several processes exist for toning or altering the color of a silver image. If you want a sepia or brown tone, the most suitable methods are the hypo-alum process and the bleach-and-re-develop sepia process. Not all such processes are suitable if the prints are intended for long-term keeping. Prints that have been toned by one of the processes that convert metallic silver to silver sulfide or silver selenide are generally more stable than untoned prints or prints toned by other methods. In recent years, toning has been recommended as a way of achieving maximum image stability. See Kodak publication F-40, *Conservation of Photographs,* for this information.

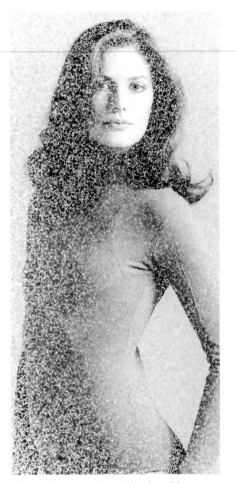

Normally exposed print developed by spattering developer through a screen with an old toothbrush.

After being exposed, the paper was placed, emulsion side up, in the bottom of a dry tray. Then a small amount of developer was splashed onto its surface and allowed to remain for the duration of development.

SELECTIVE PROCESSING

By varying your method of development, it's possible to change the quality of the image on photographic paper in a variety of creative ways. By painting, sponging, spraying, spattering, or splashing small amounts of developer onto the emulsion side of a dry sheet of exposed paper, you can make the image appear in only certain areas. Or you can make it appear spotty throughout the picture area. The effects produced can often look as though a heavy texture screen was used during exposure.

Start by making a test strip to determine the best exposure for normal development. Then expose a fresh sheet of paper at the exposure you selected from the test strip. There are several ways to apply the developer, each producing its own effect. Materials you may want to try include a small paint brush, paint roller, tooth brush and screen, atomizer, coarse sponge, and pad of cotton. Use a minimum amount of developer for more pronounced effects.

After applying the developer, let it lay on the paper surface for the full length of normal development. Then rinse the print in stop bath, and fix, wash, and dry normally.

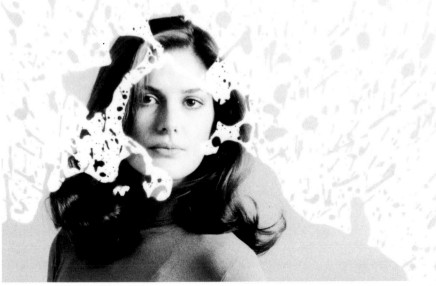

STABILIZATION PROCESSING

Stabilization processing is mechanized, fast, and easy. You feed the exposed paper into the processor, and about 15 seconds later the print emerges from the machine fully processed and damp-dry. The print is not permanent as stabilized, but can last for several months if not subjected to excessive heat and humidity or exposed to intense light for long periods. The life expectancy of stabilized prints can be extended considerably by fixing, washing, and drying conventionally. A stabilization processor takes up comparatively little space, the basic process requires little or no water, and only two chemicals are normally needed. The stabilization process is a viable alternative to tray processing when speed and convenience are more important than print stability and low initial equipment cost.

Stabilization processors

Stabilization processors are electrically powered machines designed to transport a sheet of specially formulated photographic paper through a set of processing rollers at a constant speed. The rollers first apply activator to the paper emulsion to develop the image very rapidly, then follow with an application of stabilizer to stop the process and render the image relatively insensitive to light. The paper emerges from the machine almost dry. Complete drying occurs in the room environment, with no special treatment required or recommended.

Stabilization processors are available from several manufacturers in a variety of sizes. Choose one that can accept the largest paper size you expect to use routinely, but be realistic. Don't buy capacity that you will not actually use. Also, be sure the stabilization processor can be utilized with the stabilization papers and chemicals you wish to use. Not all

THINGS YOU'LL NEED

1. Stabilization processor
2. Stabilization chemicals (activator and stabilizer)
3. Stabilization printing paper

With a stabilization processor, you merely start the paper into the machine short edge first. The processor does the rest. Be sure to check the operating instructions to determine whether the paper should be inserted emulsion up or emulsion down.

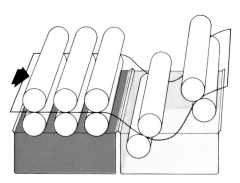

Rollers in a stabilization processor drive the paper along its path through the machine, and apply activator to develop the image quickly and stabilizer to render it relatively insensitive to light. The print emerges almost dry in seconds.

paper/chemical systems are recommended for use with all processors. Consult manufacturers' literature for details.

Temperature control

Other than maintaining a tolerable ambient temperature in the processing area, no special temperature control techniques are needed or feasible with stabilization processing. With KODAK EKTAMATIC Chemicals, 70°F *21°C* is considered ideal, but the useful range is from 65°F to 85°F *18°C to 29.5°C.*

Stabilization chemicals

Most stabilization processes require two chemicals: an activator and a stabilizer. They are usually supplied ready to use in sealed bottles. Depending on the processor design, the bottles may mount on the machine and serve as reservoirs feeding internal troughs, or you may have to fill internal reservoirs with the appropriate chemical. Be careful to fill the machine correctly, according to the manufacturer's instructions. Don't allow stabilizer to contaminate the activator supply, as print staining and fogging will result.

Stabilization chemicals are available from a number of sources, including Kodak. For best results, use chemicals specifically recommended for the stabilization paper and processor you have. Observe manufacturers' recommendations about how long you may keep used chemicals in the machine, and don't overwork solutions by running too many prints through a given quantity. Clean the processor as recommended to prevent chemicals from caking on working parts and causing uneven development.

Stabilization printing paper

Stabilization papers incorporate chemicals in the emulsion that make the image develop in seconds on contact with the activating solution. These chemicals are not necessary in conventional photographic papers, which cannot be processed by the stabilization method. However, stabilization papers can be processed conventionally in trays should the need arise. The development will be very rapid however.

Selective-contrast stabilization papers, such as KODAK EKTAMATIC SC Paper, permit contrast adjustment by means of appropriate filter selection when enlarging. Graded-contrast stabilization papers are also available. Be sure the paper you select can be used with your processor and chemicals.

After filling the processor with chemicals, wash your hands thoroughly and dry them before handling stabilization paper. Even tiny amounts of chemical deposited on the print emulsion can leave unsightly marks when the print is processed.

Extending the life of stabilized prints

If you wish to keep a stabilization print more than a few months, additional treatment is needed. Specific recommendations will vary according to the specific product. Generally, the procedure entails treating the print in a conventional fixing bath, washing it thoroughly—with or without a washing aid—and drying it as you normally dry prints. Prints treated in this manner can also be toned, if you wish. Untreated stabilization prints should not be toned.

Storing stabilization prints

Stabilization prints may stay in good condition for months if protected from high heat, humidity, and bright light. However, they should not be kept in close contact with conventionally processed photographic prints. The latter may be adversely affected by chemicals remaining in the former. Stabilization prints that have been fixed, washed, and dried display the same excellent longevity as properly processed conventional papers, and may be stored with them without difficulty.

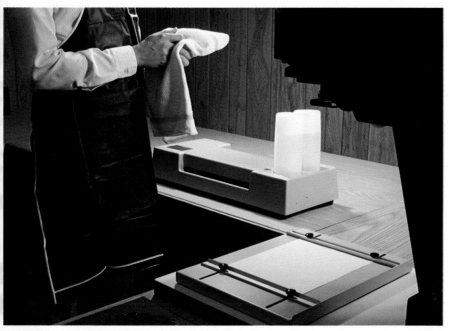

After you have charged a stabilization processor with chemicals, wash your hands thoroughly and dry them before handling stabilization paper. Even tiny traces of chemical remaining on your hands can cause marks and stains if transferred to the paper emulsion. Pictured here is the Spiratone Print-All stabilization and rapid print processor.

Photographic papers

Black-and-white photographic papers for making contact prints and enlargements are available from Kodak and other manufacturers in a profusion of choices to meet nearly every conceivable need and preference. Understanding the major differences among them will help you choose materials that will serve you well both technically and aesthetically.

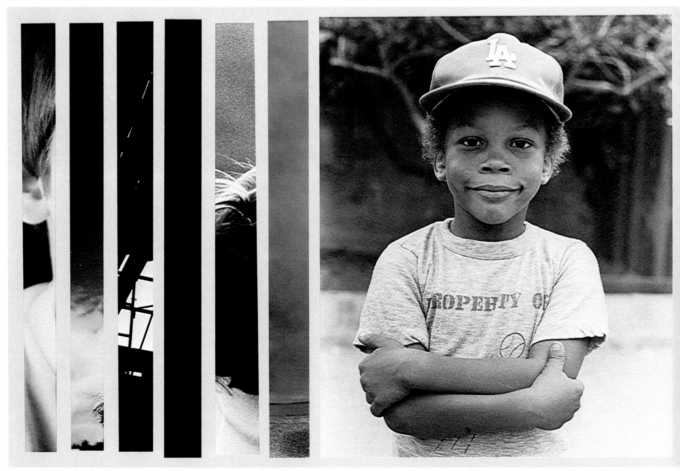

CHOOSING YOUR PAPERS

If you are just beginning to print, take a popular enlarging paper such as KODAK POLYCONTRAST Rapid II RC, KODAK POLYPRINT RC, or KODABROMIDE Paper. Stay with that paper long enough to develop a feel for the way it reacts to different types of negatives and printing procedures. You may find you can live happily with your initial choice. Many people do. In case you feel you would prefer to use a paper with different characteristics, try some likely candidates and compare them with the paper you have already learned to use. If you switch papers often in the beginning, it will take longer to become a good printer than if you stay with one product for a reasonable period. Learning to print is like learning to play a musical instrument. Practice with a particular instrument of known response is more valuable than practice with a variety of instruments of unknown response.

CONTROLLING CONTRAST

You can differentiate black-and-white printing papers according to their means of controlling contrast. This is an important distinction that has technical, aesthetic, and economic ramifications.

Graded papers

Many photographic papers are manufactured in individual contrast grades ranging from very low to very high. The contrast grades can be described numerically or verbally. For example, KODABROMIDE Papers are available in contrast grades numbered 1, 2, 3, 4, and 5, with higher numbers denoting higher contrast. You may find other papers available in similar contrast grades, but designated as ultra soft, soft, medium, hard, extra hard, and ultra hard. Normal contrast negatives generally print well on contrast grades No. 2 or the medium grade.

Most papers are available in fewer

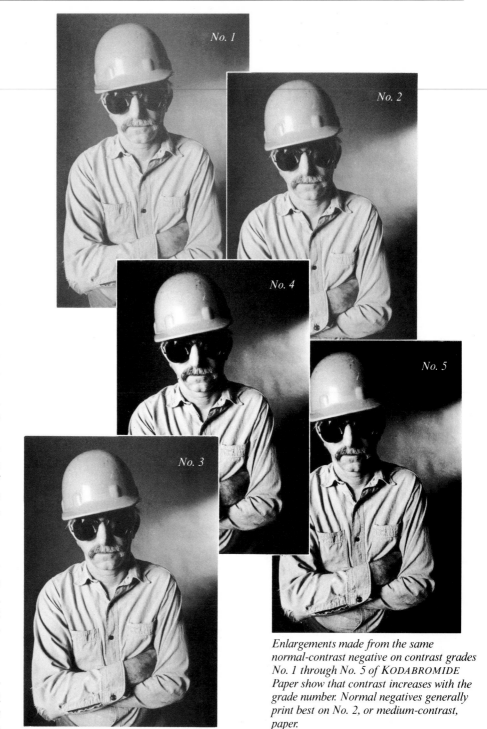

Enlargements made from the same normal-contrast negative on contrast grades No. 1 through No. 5 of KODABROMIDE Paper show that contrast increases with the grade number. Normal negatives generally print best on No. 2, or medium-contrast, paper.

than five contrast grades. Some offer a sixth grade. Contrast designations are not necessarily uniform from one brand of paper to another. It isn't uncommon for a given grade in one product line to correspond to a grade numbered higher or lower in another. Contrast designations do tend to be uniform within brands.

Graded papers provide the greatest range of contrast control, particularly at the high-contrast end of the scale. However, to benefit from this range you must stock a separate envelope or box of paper in each grade. Darkroom workers who prefer graded papers frequently stock large quantities of the contrast grade or grades they use most often, and much smaller quantities of grades they seldom use.

Graded papers are generally compatible with all light sources commonly used for contact and projection printing.

75

Contrast-control filters such as these new KODAK POLYCONTRAST II Filters alter the contrast response of selective-contrast papers. These new filters provide an expanded range of 11 different contrast grades from Grade 0 to Grade 5 in ¹/₂-grade increments when exposed to light of different colors.

Selective-contrast papers

Selective-contrast papers are coated with a specially sensitized emulsion that produces different levels of image contrast depending on the color of the light to which they are exposed. Thus a single sheet of paper can be made compatible with a wide variety of negatives.

With KODAK POLYCONTRAST Rapid II RC, KODAK POLYFIBER™, and KODAK POLYPRINT RC Papers, the color of the exposing light is changed with POLYCONTRAST II Filters, which are now available in grades approximately equal to numbers 0, ¹/₂, 1, 1¹/₂, 2, 2¹/₂, 3, 3¹/₂, 4, 4¹/₂, and 5. Normal negatives generally print well when exposed with a No. 2 filter. These papers also yield normal, or medium, contrast when exposed without a filter.

Selective contrast papers do not always provide as extreme a range of contrast as some graded papers, but they do provide a usefully wide range conveniently and economically. A single box or envelope of paper will handle all but the flattest negatives with ease. Many darkroom workers who prefer to use selective-contrast papers also keep a small supply of extremely high contrast graded paper on hand to extend their high end options.

Selective-contrast papers are compatible with light sources used in most modern enlargers and contact printers. Generally, they are not suited to exposure by fluorescent light sources used in some types of enlarging and printing equipment. Consult the respective manufacturers if you have any doubts.

Enlargements made from the same normal-contrast negative on POLYCONTRAST Rapid Paper show contrast differences produced by printing through POLYCONTRAST Filters No. 0, 1¹/₂, 3, 5.

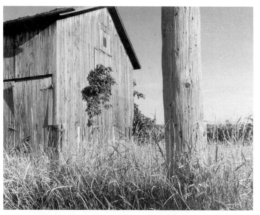

Filter No. 1¹/₂

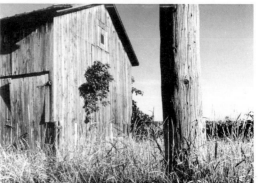

Filter No. 3

Filter No. 0

Filter No. 5

Acetate contrast-control filters made by Kodak and other manufacturers are intended to be placed above the negative. Many modern enlargers have filter drawers or slots to accept such filters, although the filters may have to be trimmed to fit.

CONTRAST-CONTROL FILTERS

Contrast-control filters offered by Kodak and other manufacturers for use with selective-contrast papers are often supplied in two or three forms: very thin gelatin, thicker plastic, or acetate. Although these types control contrast similarly; they are not interchangeable.

Gelatin filters

Gelatin contrast-control filters are of high optical quality. You can place them in the path of image-forming light without causing a perceptible change in image quality. These filters are intended to be placed beneath the enlarging lens (between lens and paper).

Kodak produces KODAK POLYCONTRAST Gelatin Filters in plain squares of various sizes, as well as plastic filters in frames that facilitate handling and mounting beneath the enlarging lens. Gelatin filters are easily damaged, so should be handled with care. Pick them up by the edges and don't touch the area that intercepts the light beam from the enlarger. Keep them covered when not in use so that they won't collect dust. If they do get dusty, clean them gently with the camel's-hair brush you used for dusting negatives. Store them away from heat, light, and humidity.

KODAK POLYCONTRAST II Filters are available in a convenient kit. The kit contains all eleven filters held in plastic filter mounts which provide protection for the filters. The kit is supplied in a hinged plastic box with a filter holder and the necessary adapters to fasten it either to the red filter post of the enlarger or directly to the lens itself.

Acetate filters

Acetate contrast-control filters are comparatively tough and durable, but are not optically fine enough to use in the path of image-forming light. They are meant to be placed between the light source and the negatives, where they can change the color of the light without affecting image quality.

Many modern enlargers are equipped with filter drawers or slots above the negative compartment, designed to accommodate acetate filters. If you have such an enlarger, you may find that the filter drawer doesn't correspond exactly to standard sizes of acetate filters. In this case, simply buy filters large enough to fill the drawer or slot, and trim off any excess with sharp scissors.

Since acetate filters have no effect on image quality when they are used as intended, you don't have to worry if they pick up minor scratches or a few dust specks here and there. Nonetheless, it is preferable to handle them carefully and keep them clean. As with the more delicate gelatin filters, store them away from excessive heat, light, and humidity.

Identify contrast-control filters

Whether you use gelatin or acetate filters, mark them prominently with the appropriate contrast designation if the manufacturer has not already done so. KODAK POLYCONTRAST Acetate Filters are edge marked with a contrast grade. If you have to trim

acetate filters to fit your enlarger drawer, confine the trimming to the unmarked edges. If necessary, write the contrast number in a corner with a marking pen.

CONTRAST CONTROL WITH COLOR ENLARGERS

Some enlargers designed for color printing are equipped with color heads that provide continuously variable internal filtration in cyan, magenta, and yellow. These filters can usually be adjusted to approximate or duplicate the color transmissions of filters used with selective-contrast black-and-white papers. Consult the owner's manual furnished with the enlarger or color head to determine what filter settings correspond to contrast-control filters for various selective-contrast papers. If your manual does not provide this information, you can contact the manufacturer or distributor for their specific recommendations. Or you can establish your own data experimentally. The accompanying table suggests starting points only for your experimentation, as actual color-head filters and light sources may vary considerably from one manufacturer to another.

For this approximate paper grade	Use this CC or CP Filter
1	40Y
2	20M
3	70M
4	300M

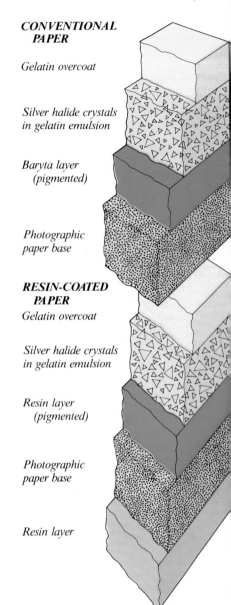

Gelatin overcoat

Silver halide crystals in gelatin emulsion

Baryta layer (pigmented)

Photographic paper base

RESIN-COATED PAPER

Gelatin overcoat

Silver halide crystals in gelatin emulsion

Resin layer (pigmented)

Photographic paper base

Resin layer

PAPER KINDS AND CHARACTERISTICS

You can differentiate between types of photographic paper by physical and photographic characteristics unrelated to the means of controlling contrast. When selecting papers for your darkroom, consider your working methods and preferences before making your choices.

Fiber-based papers

Fiber-based papers are "paper" papers. The light-sensitive emulsion is applied to a baryta-coated paper base with enough body to withstand normal handling and processing in future use. Fiber-based papers are easy to trim and mount, and you can write on the paper backing easily with ordinary pencils, pens, and stamp-pad ink. Because the paper backing is highly absorptive, fiber-based papers require relatively long washings to remove the processing chemicals and by-products before drying.

Resin-coated papers

Resin-coated papers consist of a light-sensitive emulsion on a paper base that has been coated on both sides with a water-resistant resin. Resin-coated papers are rugged and durable, wet or dry. Many ordinary writing materials and inks do not mark the non-absorptive backing permanently. Rather, use a ball-point or permanent-ink marking pen, or china marker. When processed properly, resin-coated papers require only brief washing times. They must be processed to completion without delay, because extended wet time may allow moisture to enter the paper through its edges.

Paper Speed

Like photographic film, black-and-white printing papers are available in different sensitivities to light. High-speed products, such as POLYCONTRAST Rapid II RC and KODABROMIDE Papers, are useful for making enlargements from small negatives and for making extreme enlargements from any size negative. Their high speed lets you make shorter exposures than would be necessary with a slower, less-sensitive paper.

Papers having less sensitivity are well suited to printing with larger size negatives and making small prints from negatives of all sizes. Their lower sensitivity permits working at exposure times of comfortable duration, rather than the relatively short times that would be necessary with a high-speed paper.

Relative speeds of some Kodak black-and-white papers manufactured in the U.S.A. are published in

Fiber-based photographic paper consists of a paper backing on which the light-sensitive emulsion is coated. The paper base absorbs processing solutions and by-products, so requires considerable washing.

Resin-coated paper also employs a paper base to support the emulsion, but the paper backing is coated on both sides with a water-resistant resin material. Resin-coated papers absorb little processing solution and by-products, thus wash clean very quickly.

the *KODAK Complete Darkroom DATAGUIDE*, Kodak publication R-18. Note that the speed of a particular printing paper may change with the contrast grade. Extremely high and low contrast materials are often slower than intermediate grades of the same brand and kind.

Surface textures

Kodak photographic papers and those made by other manufacturers are available in many surface finishes, ranging from smooth and glossy to heavily textured. Glossy fiber-based papers are versatile in that you can dry them to a high gloss or a softer semigloss, depending on the drying method. Glossy resin-coated papers dry to a high gloss only. Non-glossy papers cannot be dried to a glossy finish.

Glossy and semiglossy surfaces show fine image detail well, can produce an extremely wide tonal range, and are preferable when printing for publication. High-gloss finishes are usually avoided in printing for exhibition, because the mirror-like surface can reflect ambient illumination, making the image difficult to see in some circumstances.

Smooth and matt surfaces are less reflective than glossy surfaces. Matt finishes are attractive with subjects that benefit from a soft rendition and do not require great tonal range in the print.

Heavily textured, pebbled or tapestry-like print surfaces do not reproduce fine image detail well. For this reason, they are often favored for portraiture, where it is generally desirable to suppress complexion flaws. The rough surface of the print softens the rendition sufficiently to provide a form of mild, built-in retouching.

With the exception of the word *glossy*, which means much the same

Glossy papers render fine image detail distinctly and can yield a wide tonal range from intense black to brilliant white. Matt papers yield a softer rendition and a more compressed tonal range. Nonglossy prints are easier to display, as their surfaces don't produce glaring reflections.

thing to almost all photographic manufacturers, descriptive terms for print surfaces are not standardized. If you're interested in trying a paper surface other than glossy, ask your photo dealer to show you sample prints made on papers of different kinds and finishes. Paper manufacturers often provide dealers with sample books for customer reference. What you see in such books is the type of surface the paper will provide, regardless of the designation.

Image tone and stock tint

These terms refer to the overall color of the print, which is a function of two separate but related components. Image tone is the color of the dark portions of the picture, which can range from a cool, bluish black to a warm, brown or olive black. Stock tint refers to the tint of the paper base as visible in the borders and bright highlight areas of the print. Paper stocks that are not neutral white usually have warmer hues. Personal preference will count more in your choice of image tone and stock tint than will objective considerations. Again, rely on inspection of paper samples rather than on descriptive terms when making your selection.

Paper weight

Paper weight refers to the thickness of the base material. Double-weight papers are comparatively thick and strong, and resist damage even when wet. Single-weight papers are thin and easily damaged, particularly when wet. Lightweight and medium-weight papers are in between single- and double-weight papers. Resin-coated papers are generally medium-weight, but significantly stronger than fiber-based materials.

If you prefer to work with fiber-based papers, use double-weight stock unless you have a compelling reason to do otherwise. The comparatively slight premium in price will be offset by the greater number of prints that survive the rigors of processing and handling.

Some papers produce a neutral or cool image tone, while others are noticeably warmer. Choose papers by inspecting sample prints, as written descriptions of paper tones are subject to broad interpretation.

Portrait papers such as those in the KODAK EKTALURE Paper family usually have a warm image tone and a slightly warm stock tint. Textured surface finishes suppress minor complexion flaws.

SPECIAL-PURPOSE PHOTOGRAPHIC PAPERS

Strictly speaking, nearly any general-purpose black-and-white paper can produce satisfactory results over an extraordinary range of applications. Nonetheless, there are times when a paper with a particular combination of characteristics optimized for a particular use will prove preferable.

Portrait papers

Portrait papers, such as KODAK EKTALURE Paper, generally combine a slightly warm stock tint with a pronounced warm image tone. They are normally supplied in mildly to strongly textured surfaces. Portrait papers often produce best results when processed in a print developer formulated to favor warm tone materials, such as KODAK SELECTOL Developer.

Mural papers

As the name implies, mural papers are designed to facilitate the making of extremely large images. They are normally available only in very large sheet sizes such as 16 x 20 inches *40.6 x 50.8 cm* and larger, or wide rolls up to 100 feet *30.5 m* long. Mural papers often have textured surfaces to help conceal minor negative blemishes that may become apparent at extreme magnifications. And they usually possess greater than normal strength and abrasion resistance to withstand folding, rolling, and handling.

Exhibition paper

KODAK POLYFIBER Paper is an exhibition-quality paper offering all of the characteristics of a fiber-base paper. It has the same emulsion as POLYPRINT RC Paper, providing the benefits of wide selective contrast. It is ideal for commercial and studio work, etching and retouching, air brushing, and complex strip-in work. KODAK ELITE Fine-Art Paper is also an exhibition quality paper. This is the finest black-and-white paper Kodak has ever made; it reproduces the wide tonal range of superior black-and-white fine-art photography.

Mural papers are available in large sheet sizes and long rolls to facilitate making extremely large prints. They are generally stronger and more abrasion-resistant than ordinary papers.

81

Contact papers

Contact printing papers (KODAK AZO and VELOX Papers, and those of other manufacturers) are primarily intended for use with contact printing machines that typically place the light source close to the printing paper. For easier exposure control, they are much less sensitive to light than enlarging papers. Because of their low speed, they cannot be used for projection printing with conventional enlargers.

Machine-processing papers

Some water-resistant papers, including KODAK PANALURE II RC, KODABROME II RC, and POLYCONTRAST Rapid II RC Papers, incorporate developing agents into the print emulsion. This feature allows them to be processed in machines such as the KODAK ROYALPRINT Processor, Model 417. The process differs from stabilization processing in that the processor treats the paper successively in an activator, stop bath, fixer, and wash water, much as you would do manually when using trays. The machine process uses different chemicals, however, and is much faster, with dry-to-dry time for an 8 x 10-inch print taking about 55 seconds.

Activation processing, as it is known, has the advantage of yielding long-lasting prints that do not require further treatment. Activation papers can be processed manually in trays if desired, with conventional processing solutions.

Stabilization papers, discussed earlier, are also a type of paper adapted to machine processing. They are not interchangeable with activation papers, and the processes and processing machines are different.

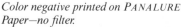

Normal color print from a KODACOLOR Negative.

KODAK PANALURE Papers

KODAK PANALURE, PANALURE II Repro RC, and PANALURE II RC Papers are panchromatic; that is, they are sensitive to all colors of light. They are used to make correct-tone black-and-white prints from color negatives. Because of their broad sensitivity to the visible spectrum, they must be handled under specific safelighting: KODAK Safelight 13 Filter with a 15-watt bulb, or 10 Safelight Filter with a $7^{1}/_{2}$-watt bulb (or equivalent). As these safelights are very dim, some darkroom workers elect to work in total darkness with these materials, using no safelight at all.

Activation papers, such as KODABROME II RC Paper, incorporate developing agents in the print emulsion. When exposed paper is transported through an activation processor such as the KODAK ROYALPRINT Processor, Model 417, it is treated successively in activator, stop bath, fixer, and wash water. Activation processing is essentially a very fast, mechanized variation of conventional print processing.

Color negative printed on PANALURE Paper—no filter.

PANALURE Paper is a fiber-base paper with fast printing speeds. It has applications in commercial, portrait, and school photography. It can also be used for making black-and-white enlargements from color negatives or contact prints from color negatives. PANALURE II RC Paper is a projection-speed, panchromatic, black-and-white enlarging paper. Its resin-coated base allows rapid tray or machine processing and drying. PANALURE II Repro RC Paper offers lower contrast than PANALURE II RC Paper, making it especially suited for accurate photomechanical reproduction.

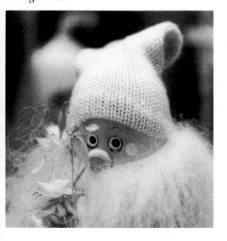

A No. 25 red filter was used during printing on PANALURE Paper to lighten the red hat, helping to separate the subject from the background.

STORING UNEXPOSED PAPERS

Black-and-white photographic paper keeps for a very long time in a cool, dry environment, away from chemical fumes and other atmospheric pollutants. Store the paper in the original envelope or box, including the interior black envelope or wrapping. Tape envelope flaps and box tops shut between darkroom sessions to prevent accidental opening.

Large quantities of paper should be stored on edge, rather than stacked. The weight of a heavy stack of paper can cause random pressure marks to develop along with the image on sheets from the bottom of the pile.

If you do much printing, you can economize to some extent by buying paper in large quantities at long intervals rather than in small quantities frequently. The cost per sheet tends to be lower with large packages. But don't buy a long-term supply if your storage conditions are less than optimal. Treat photographic paper with respect. It is, after all, a vehicle of your vision.

If you keep a large quantity of paper, store it on edge rather than stacking it. Stacking subjects paper near the bottom of the pile to excessive pressure that can cause odd blotches and tonal variations to develop with the image.

PRINT STABILITY

If you have been following recommendations for print fixing, print washing, and use of wash aids, you already will have attained an excellent level of stability in your prints. Your black-and-white prints will last a long time without additional treatment. Just continue to follow the steps for print finishing, mounting, storage, and display.

Only if you feel that you would like to provide added protection from the possible effects of strong light, sulfurous atmosphere, and other harmful gases, do you need to consider any other print treatment. Of course, if you are planning to tone your prints anyway, you will also be making the image more stable. Maximum image stability is obtained by washing all prints, films, and plates thoroughly with water or KODAK Hypo Clearing Agent and treating with appropriate diluted toners. Toning either resin-coated or fiber-base prints with most Kodak toners extends the life of the prints. Toning methods that convert all or substantially all of the image to silver sulfide or silver selenide are less susceptible to attack by oxidizing gases in the atmosphere. (See pages 70 and 71 for details on print toning.) Partial toning of prints in KODAK Rapid Selenium Toner changes the original tone of the print only slightly or not at all but provides good stability to oxidizing gases. Toners that contain gold chloride such as KODAK Gold Protective Solution GP-1 are slightly less effective than the toners mentioned above.

KODAK Hypo Eliminator should never be used on films or plates intended to be stored under long-term or archival conditions. It should also never be used instead of a proper wash but only to remove the last traces of hypo from prints and only when these traces of hypo would create a problem in a subsequent toning process. For reasons still unknown, the adsorption of hypo by paper fibers can interfere with toning reactions. For more details about permanence and for formulas of solutions mentioned here, see Kodak publication F-40, *Conservation of Photographs.*

Generally, properly processed black-and-white prints on resin-coated base can be expected to last as long as fiber-base prints. However, certain display conditions, such as intense light, frequent temperature or humidity cycling, or rapid changes in moisture content, can have detrimental effects on resin-coated black-and-white prints. For those applications requiring long-term keeping under adverse storage or display conditions, toning of resin-coated or fiber-base prints can provide protection against these conditions.

Print finishing

A print that is dry is not necessarily a print that is finished. No matter how good your enlarging technique may be, you will often find small white specks in dark print areas, caused by dust particles on the negative. You may decide, too, that the print will look better if it is trimmed to a slightly different format or presented without a white border. And you may wish to endow the print with better presence and greater durability by mounting it.

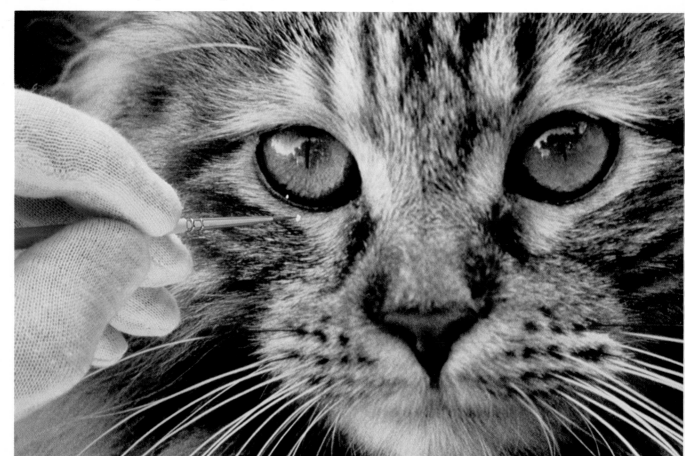

Removing dust marks by spotting, altering the format by trimming, and enhancing the effect by mounting are the three major forms of print finishing. They are not difficult, and they have a disproportionately great effect on the way a photograph is perceived. Appearance counts.

PRINT SPOTTING

Print spotting is the remedy for white dust specks on the print. Use a fine-pointed spotting brush to apply dyes called spotting colors to the light areas until they blend into the surrounding image tone and become either less noticeable or altogether invisible.

Spotting colors

Spotting colors, such as the Spotone series, are available in tiny bottles of liquid through photo specialty stores. Colors include blue black, selenium brown, neutral black, olive black, brown, and sepia. You can mix them to match nearly any conceivable image tone, and blend them in quantity for future use. In addition, a small tube of white opaque watercolor paint comes in handy for concealing occasional dark, pinhole spots that pop up in light areas of a print.

Spotting brushes

Spotting brushes should be very fine tipped, because a fine tip makes it easier to place the spotting color precisely. Suitable brushes are available through photo dealers and art-supply stores. Traditional favorites are tip sizes No. 0, 00, and 000, which might be described as fine, very fine, and ultra fine. You will never make a mistake by buying a spotting brush with a tip that looks much finer than you think you need. It will become your favorite.

Fine-tipped artist's brushes in tip sizes No. 0, 00, and 000 are excellent for spotting prints. Such brushes are available through photo dealers and art supply stores.

Mix drops of water and spotting color in a white dish until the mixture is slightly lighter in tone than the area you are trying to match. You can control the buildup of density in the area you're spotting better with repeated applications of a light mix.

MATCHING PRINT TONE AND DENSITY

When spotting a print, you should attempt to both conceal the original flaw and leave little or no trace of the corrective measure. This requires matching the spotting color closely to the print tone, and applying just enough to match the adjacent print density.

Before you start spotting good prints, practice on discarded prints made on the same type of enlarging paper. Mix spotting colors until you arrive at a blend that is as neutral, as cool, or as warm in tone as the paper. That will be the basic mix you use each time you spot that particular brand and type of enlarging paper.

Match image density by applying just enough color to the spot to conceal it, without forming a darker spot of dye. Unless you're working on a spot surrounded by deep black, you will have to reduce the strength of the dye slightly. Use a small white dish or ash tray as a mixing palette. Add water on the tip of the brush to a drop of dye on the mixing surface until the mixture looks slightly lighter than the image density it will have to match.

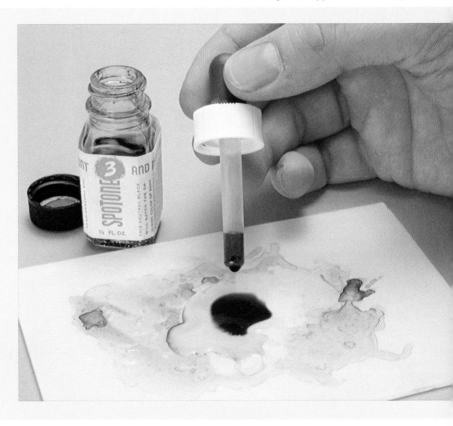

This print was made from an uncleaned negative that had collected dust while sitting uncovered for several months on a counter.

APPLYING THE SPOTTING COLORS

Pick up some of the diluted spotting color on the tip of the brush, and draw the brush lightly along the mixing surface while rolling or rotating it to remove excess dye, and shape the tip to a fine point. If too much dye remains on the brush, roll it lightly against a piece of cardboard blotter or paper toweling. The tip should be damp with dye, not wet.

Gently touch the tip of the brush to

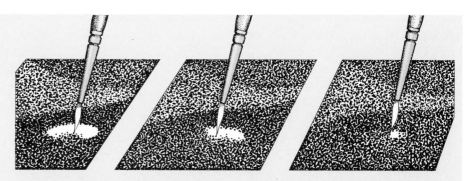

the spot and pull it back. Repeat this stippling or dotting action until the spot appears almost as dark as the surrounding area. Let the spot dry a few seconds before continuing. The area worked on continues darkening slightly as it dries. For the best match, you're safer stopping a moment before you think the spot is dark enough. You can always darken it further if necessary.

Keep a tissue or tuft of cotton within reach to blot excess dye from the print surface quickly if an overly wet brush releases a drop instead of a dot. You can save time by first spotting areas that need the most darkening, shifting to other areas as the charge of dye on the

brush becomes depleted. The dark areas will absorb the excess you would be wiping from the brush before starting on the lighter areas.

Rinse brushes clean in water after use, and let them air dry before putting them away.

If you expect to hot-mount a print, do the spotting after the print is mounted. Some spotting dyes may change color and density when subjected to heat. Such changes are unlikely to be obtrusive in very small areas, but can be noticeable if spotting colors have been used to build density in larger areas. In any case, a mounted print is easier to handle.

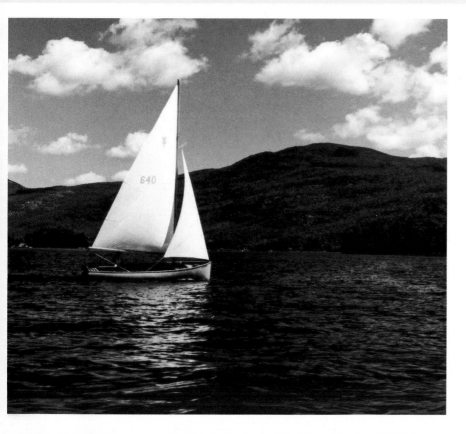

Print spotting conceals white dust marks and other light-toned imperfections by darkening them to match adjacent print densities.

TRIMMING PRINTS

Standard paper dimensions are suitable for many pictures, but there are times when a photograph may look better in a more elongated or more square format. At other times you may feel a picture will look better with no white border. Or you may simply wish to change the cropping for some reason of your own. Aesthetics aside, you will want the trimmed print to have cleanly cut, straight edges, parallel opposing sides, and 90-degree corners.

Trimming a print may be the most effective way to crop a picture that looks best in a format substantially different from standard paper dimensions.

BASIC TOOLS FOR TRIMMING PRINTS

A simple print-trimming outfit consists of a heavy-duty, single-edge razor blade or sharp mat knife, a metal straightedge or T-square, and a plastic drafting triangle. Use the metal straightedge or T-square to guide the cutting blade, and the triangle to check that each edge is cut at 90 degrees to its neighbors. Run a strip of masking tape lengthwise along the bottom surface of the straightedge to keep it from slipping while you cut.

Put a large sheet of heavy cardboard or an old, thick mounting board beneath the print while you trim it. Otherwise the blade will mar the work surface. Change blades frequently, because a dull blade tends to tear photographic paper rather than cut it cleanly. Make each cut over a different section of the backing board to avoid digging a trench in it that could trap the blade and force it off a straight path. And change the backing board when you have trouble finding an unused area above which to cut.

You can trim prints neatly with a mat knife or single-edged razor blade. Carefully guide the blade with a metal straightedge, true up corners with a drafting triangle and cut the print over a piece of heavy cardboard to avoid marring the work surface.

Mechanical cutters

Rotary or swinging-blade paper cutters make quick work of trimming prints. Check the paper alignment guides, if the cutter is so equipped, to make sure the cuts will be at right angles. Periodically check both the blade and the metal edge against which it cuts. Have the blade sharpened professionally when it becomes dull. Replace the metal edge piece when it wears enough to develop slight curvature.

For best results, hold the print as flat as possible while you trim it, particularly near the edge being cut. Large trimmers sometimes have a clamping bar parallel to the cutter to hold the print down firmly. Don't use rotary or swinging-blade cutters to cut heavy mount board. The force required will eventually spring the cutter out of alignment. Use a mat knife and straightedge, instead. Several light cuts along the same track will cut through the heaviest mount board. It's a slow procedure, but better than wrecking a good paper cutter.

Rotary cutters feature a circular knife enclosed in a safety shield. To operate one, pull the cutting assembly along its built-in track, across the print edge being trimmed.

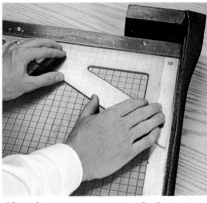

If you have a paper cutter with alignment guides, check them with a triangle to make sure the adjoining edges of prints you trim will be at right angles. Adjust the guides if necessary.

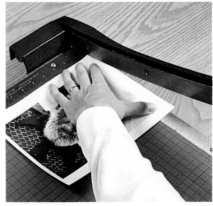

Hold the print flat along the cutting edge with your hand or a built-in clamping bar if the cutter has one. Keep your fingers clear of the blade.

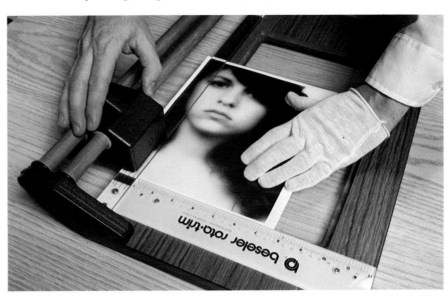

MOUNTING PRINTS

You can make a good print look better and enhance its durability by mounting it on a sturdy backing. Mount boards range from relatively thin card stock to such durable materials as Masonite hardboard and metal plates. For most normal purposes, choose light- to heavy-weight photographic mount boards. If a print is good enough to mount, resist the temptation to save money by using scrap cardboard for your backing. Many nonphotographic paper products contain chemicals that can cause deterioration of a photographic image. Stick with mount boards made specifically for photographic use if you want the print to last as long as possible.

Mounting methods fall into two distinct categories: hot mounting, which requires an electrically heated press and temperature-sensitive bonding tissue; and cold mounting, which uses adhesives at room temperature.

Hot mounting

For efficient hot mounting, you need an electrically heated dry mounting press with a platen and bed large enough to accept the largest mount you wish to use. Dry mounting presses are available from several manufacturers in a variety of sizes. Be realistic about your mounting needs, because small increases in press size mean big increases in price. You also need a supply of heat-sensitive mounting tissue, such as KODAK Dry Mounting Tissue, Type 2, in sizes appropriate to your needs, and an electric tacking iron. This is the recommended adhesive for conservation mounting.

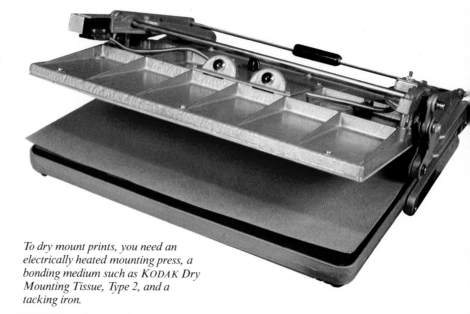

To dry mount prints, you need an electrically heated mounting press, a bonding medium such as KODAK Dry Mounting Tissue, Type 2, and a tacking iron.

HOT MOUNTING

Before using a new press, read the operating instructions carefully and follow all recommended procedures. Also read the data sheet pertaining to the enlarging paper you used and the instructions supplied with the dry mounting tissue.

Before heating the press, open it as far as you can and wipe off the platen with a clean, soft cloth to remove any dust or grit that may have settled there. The platen must be perfectly smooth and clean or it will emboss imperfections into the print surface. If there are any stubborn deposits on the platen that will not wipe off, consult the owner's manual or the manufacturer for advice on appropriate cleaning solvents. Never try to scrape the platen clean. You risk damaging the surface. Wipe the bed on which the mount will rest, too.

Cut a large sheet of kraft paper to place between the print surface and the platen. It protects the print emulsion from minor surface imperfections of the platen, and keeps the platen from accumulating particles of mounting tissue and print emulsion. Protective sheeting made for this purpose is also available through photo dealers.

Following the manufacturer's directions, switch on the mounting press several minutes before you intend to use it so that it will reach the proper operating temperature. Set the heat to

produce a platen temperature between 180°F and 210°F *82°C and 99°C*. This range is safe for Kodak resin-coated and fiber-based black-and-white papers. Consult data sheets for specific recommendations applicable to other manufacturers' products.

When the press is hot, bake each mount board in it for about 30 seconds or longer on each side to drive out moisture that it may have absorbed

from the atmosphere. Briefly heat the cover sheet to also remove residual moisture which might otherwise cause it to stick to the face of the print.

Select a sheet of mounting tissue and trim it roughly to the size of the print.

Cold mounting

There are other adhesives that can be used in the cold-mount method. This method is similar to the dry mounting tissue method but does not require the application of heat. Products that are used with this technique are pressure-sensitive, double-sided adhesives that are positioned first on the photograph and then rolled or squeezed to bond the adhesive to the print. After removal of the liner, the other side is then bonded to the mounting board by rolling or squeegeeing. Adhesive tapes may also be used in cold mounting. Mounting with adhesives is applicable to both fiber-based and resin-coated papers.

From a practical standpoint, you can mount a print that need not last long with just about any adhesive you have on hand. If you are concerned with the lasting quality of the image, however, use only adhesives and bonding materials specifically formulated for photographic applications. Other types may contain chemical agents that cause deterioration of photographic images. As in hot mounting, follow instructions precisely to secure positive adhesion. For information on mounting for long-term preservation, see Kodak publication F-40, *Conservation of Photographs*.

Mounting permanence

Most of the hot and cold mounting methods outlined above are essentially permanent, there being no practical way to separate the print from the mount without damage. If you decide in the future that you prefer a picture unmounted, your only option is to head back to the darkroom to reprint it. At this point, though, that should not pose a problem.

Place the print face down on a clean, smooth surface and place a sheet of mounting tissue over the back. With the heated tacking iron, attach the tissue to the center of the print in the shape of an "X." If you plan to mount the print onto an oversize mount board that will form the border for the image, now's the time to trim the print and attached mounting tissue to final size. Otherwise simply trim away excess tissue that projects beyond the edges of the print.

Place the print with its attached mounting tissue face up on the mount board and move it until it is exactly where you want it. Hold the print in position while lifting a corner enough to slide the tip of the tacking iron under it. With the tip of the tacking iron, simultaneously press a corner of the mounting tissue against the mount board and gently move the iron outward toward the extreme corner, tacking the tissue to the board. Now do the same at the adjacent corner. The print is now attached to the mounting tissue in the center, and the tissue is attached to the mount board at two corners. Check the surface of the print to see that it is free of particles that could become embedded in it. Cover it with the protective sheet.

Slide the mount board plus print, covered with the protective sheet into the press, with the print facing the platen. Gently close the press. Rapidly open and close it several times to allow any moisture to escape. Then close it firmly for at least 30 seconds. If the mount is thin, 30 seconds is long enough. With a thick mount, longer heating is preferable. When the time is up, open the press and remove the mounted print.

As soon as you have removed the mounted print from the press, place it face down on a clean, dry, smooth surface and put weight on it until it cools. One or more telephone directories will do nicely. This prevents the mounted picture from warping excessively while the print and mount reabsorb atmospheric moisture. Some curvature of the mount is normal and generally unavoidable.

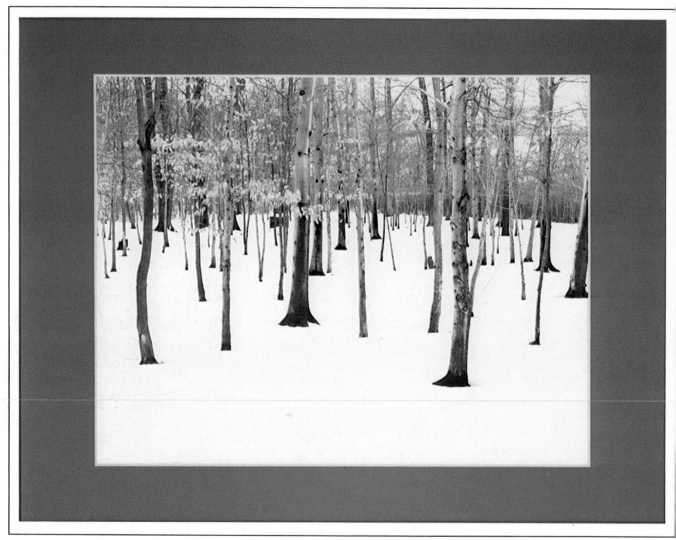

*The graphic harmony of gray bark against snow is enhanced, **above,** by the addition of a gray mat. Nonglare glass protects the finished assembly from dust and fingermarks.*

FRAMING AND DISPLAYING

Once you have perfected the techniques for printing and finishing top-quality black-and-white photographs, it's time to display some of your artistic successes. Picture frames are by far the most popular method of display. They are commercially available in many standard sizes in a wide range of materials—from various finishes of wood and metal to bright colored plastic boxes. Consider the mood you are after and the overall decor of the room. Then choose a frame to match the situation. Framing kits are also available through art-supply stores for do-it-

*Clear plastic forms, available at department stores in shapes ranging from cubes and cylinders to little houses, **left,** make clever three-dimensional display units for small prints.*

A 5 x 7-inch enlargement is given a more important presentation by displaying it in an oval mat, surrounded by an 8 x 10-inch wooden frame.

yourself assembling. If you have a special photograph and want it set off with an extra touch of elegance, you may want to take it to a custom framing shop.

When hanging your completed masterpiece, visually balance it in relation to the size and shape of the wall and to other furniture in the room. Also consider the viewing height. Pictures usually seem to appear best on a wall when hung at the viewer's eye level. If you are displaying several photographs in a grouping, it's a good idea to plan the arrangement first on paper before pounding in any nails. One way is to make miniature paper cutouts to scale of each photo to be hung, moving them around on the paper until you are satisfied with the grouping. Another method is to cut paper to the actual sizes of your mounted work and temporarily attach them to the wall with masking tape. Then it's a simple task to adjust them in different directions until the arrangement is in balance.

This informal grouping covers nearly an entire wall in a family room. Each print is backed with a wooden frame that is flush with the picture mount, providing additional support and relief.

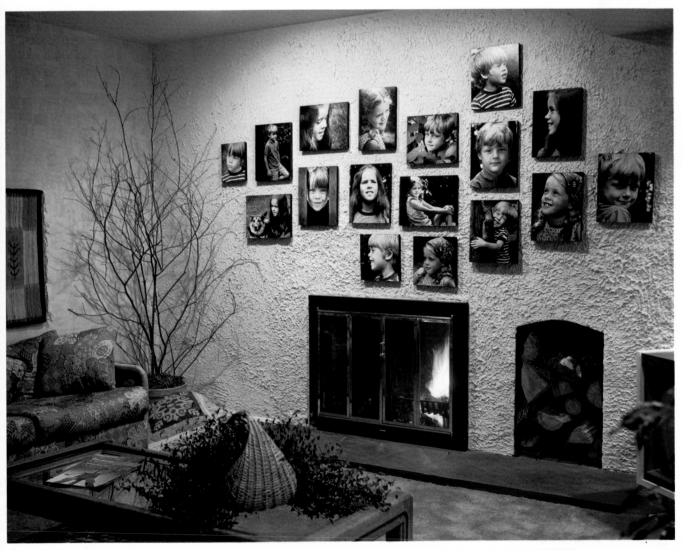

the KODAK Workshop Series
Existing-Light Photography

KODAK Workshop Series

Each one an exciting new adventure in photography

Get the whole series, and get more out of your pictures! The Workshop Series is a prime source for imaginative photographers who want facts, ideas, and inspiration. Select subjects that meet immediate need—or get all 12 for reference. Available where Kodak books are sold.

Using Your Automatic/ Autofocus Camera

Provides a thorough understanding and working knowledge of today's automatic cameras. Tells how to make automation responsive to photographic needs.

Electronic Flash

Well-illustrated, provocative ideas that explore both practical and creative effects possible with electronic flash. Complete technical information, too.

Building a Home Darkroom

Tells how to do it right—with discussions of locations, electricity, plumbing, safety, environment, and step-by-step construction. Case histories. Illustrated with real darkrooms.

Using Filters

Explains and illustrates use of filters as tools to fine-tune colors ... and how to use them to create exciting picture magic. Includes techniques for both color and b/w photography.

Color Printing Techniques

A step-by-step treatment that keeps theory secondary to the fun and excitement of making color prints. Simple as well as complex processes are explained.

Black-and-White Darkroom Techniques

Like having an experienced friend at your elbow! This book guides readers through the complexities of b/w film and print processing with easy-to-grasp explanations.

The Art of Seeing

Devoted to expanding an awareness of picture possibilities. Explains how to shed inhibitions and see as the camera lens sees. A refreshing, provocative guide.

Darkroom Expression

A step-by-step exploration of creative image manipulation beyond basics. Features the latest in new products for amateur darkroom enthusiasts.

Close-up Photography

Exceptionally well-illustrated, how-to exploration of a fascinating subject. Covers lighting, focusing, and exposure. A most definitive work on the subject.

Existing-Light Photography

First how-to book to explore the extensive capabilities of KODACOLOR VR 1000 Film. Includes exposure and other information for low-light-level photography.

Lenses for 35 mm Cameras

Must-reading and reference for those making full use of interchangeable-lens cameras. Covers fisheye, wide-angle, normal, telephoto, and zoom lenses—uses and buying tips.

Advanced B/W Photography

A salute to the renaissance of black-and-white photography. Features latest techniques for achieving high-quality work with the camera and in the darkroom.